DATE DUE			
NOV 31 00			
JE 11 01			
OCT 9 01			
NO 12 03			
MAY 2 7 2009			
OCT 0 6 2010			
APR 0 6 2011			

2016

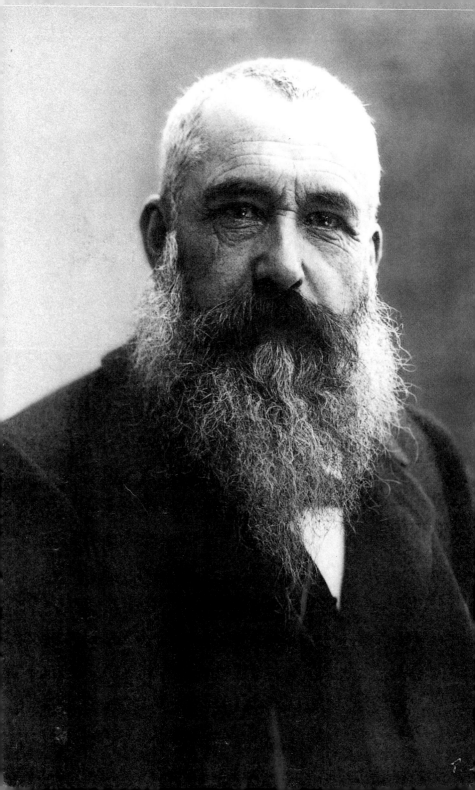

ArtBook
Monet

DORLING KINDERSLEY
London • New York • Sydney • Moscow
Visit us on the World Wide Web at http://www.dk.com

Contents

How to use this book

This series presents both the life and works of each artist within the cultural, social, and political context of their time. To make the books easy to consult, they are divided into three areas that are identifiable by side bands: yellow for the pages devoted to the life and works of the artist, light blue for the historical and cultural background, and pink for the analysis of major works. Each spread focuses on a specific theme, with an introductory text and several annotated illustrations. The index section is also illustrated and gives background information on key figures and the location of the artist's works.

1840–1858

1859–1871

1913–1926

Index

■ Page Two:
Photograph of Monet taken by Nadar.

1872-1883

1884-1899

1900-1912

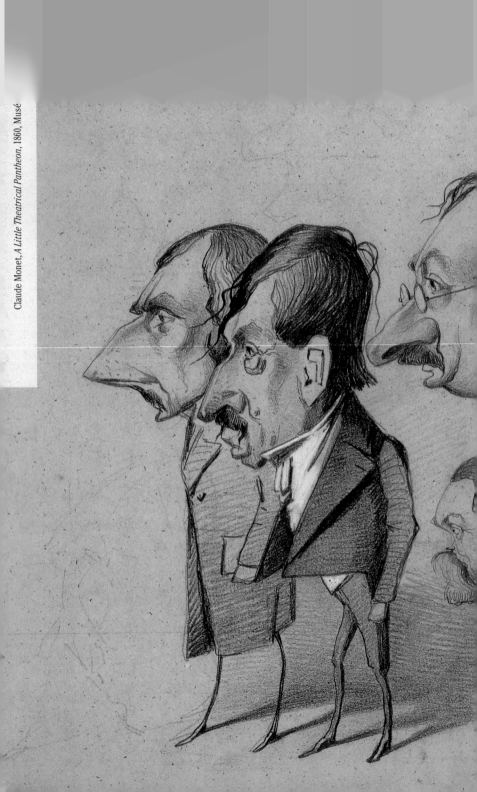

In search of a style

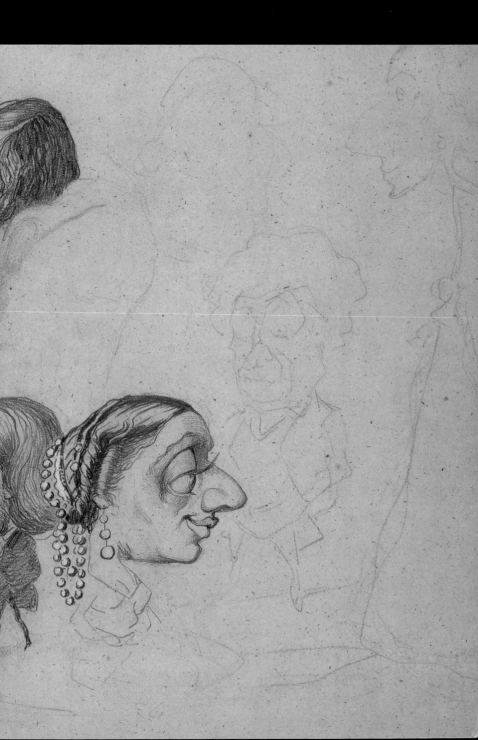

The young caricaturist

Claude-Oscar Monet was born on November 14, 1840, in Paris, at number 45 rue Lafitte. His father was a shopkeeper and in 1845 the family moved to Le Havre, a busy port on the Normandy coast. Much of his childhood from then on was spent in the countryside and near the sea, under the open skies and in continually changing climate and light conditions. After leaving school, the young Monet enjoyed his first taste of artistic success. A self-confident youth, he drew many caricatures of the citizens of Le Havre between 1856 and 1858, which were first displayed in an artist's materials shop and sold well. Here he met his first mentor, Eugène Boudin, a virtually unknown artist who ran the shop and encouraged him in life painting; the boy produced a series of small, realistically painted canvases depicting scenes from the area surrounding Le Havre. Boudin suggested he abandon caricature altogether and, instead, "study, learn to see and to draw, to paint, to create landscapes". Later, Monet would recall that Boudin "lifted a veil from his eyes", helping him to appreciate his natural surroundings.

■ Claude Monet, *Studio Corner*, 1861, Musée d'Orsay, Paris. This is an impressive still life in the manner of Courbet.

■ Below, left: Claude Monet, *Eugène Boudin Working at Le Havre*, 1857, Private Collection.

■ Claude Monet, *The Notary Léon Marchon*, 1855–56, Musée Marmottan, Paris.

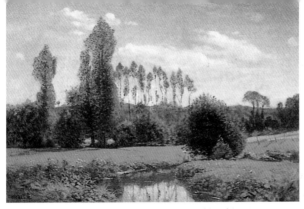

■ Claude Monet, *View Near Rouelles, Environs of Le Havre*, 1858, Private Collection, Japan. This work, remarkable for its clarity, was shown at the Le Havre civic exhibition (August–October 1858) and marks Monet's "official" entry into the art world.

The northern light

This photograph shows the harbor at Le Havre. Many artists were drawn to the town, and Boudin said that to experience its unique northern, coastal climate was "to swim in the clear sky, to touch the softness of the clouds, to suspend these masses, which are so far away". After the Impressionists, the Pointillists and the Fauves would in turn be inspired by the Normandy light.

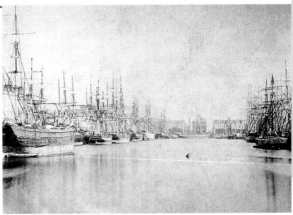

■ Jean-Baptiste-Camille Corot, *The Italian Goatherd*, 1847, Musée du Louvre, Paris. Corot's work provides a supreme example of naturalism.

■ Formerly the parish church of the kings residing in the Louvre Palace, the church of Saint-Germain l'Auxerrois in Paris is one of the major Gothic buildings in France.

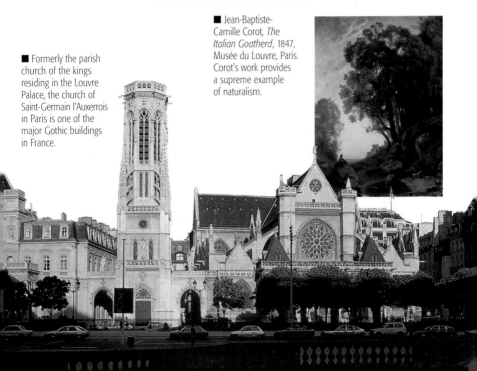

A new freedom
of expression

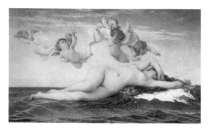

■ Théodore Rousseau,
The Pond, 1835, Museé
du Louvre, Paris.

While the young Monet was growing up, art in France was undergoing a fundamental change. From the 1830s, artists had slowly but consistently begun to distance themselves from the precepts put forward by the Paris École des Beaux-Arts, opting instead for an increase in freedom of expression in both style and subject matter. The classical rule, which specified that good drawing must be the foundation of any work, began to lose its relevance and be superseded by a new theory, which several artists now put forward: this was the representation of objective reality in as lifelike a way as possible by means of color. The Salon of 1824 precipitated something of a crisis through the inclusion of works by innovative landscape artists such as the Englishman John Constable, who promoted a more realistic technique. At the forefront

■ Porcelain pot-pourri
jar signed by Jacob
Mardochée, c.1840,
Musée des Arts
Décoratifs, Paris.
Mardochée rediscovered
earlier Rococo forms.

of the new artistic approach were the Barbizon School painters (a group of landscape artists who took their name from the village on the outskirts of the Forest of Fontainebleau). They practiced painting *en plein air*, an approach that until then had only been used make preliminary sketches for a work.

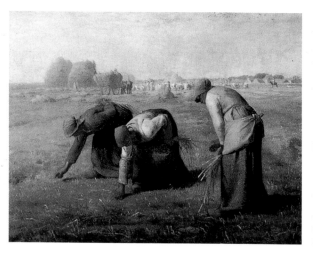

■ Alexandre Cabanel,
Birth of Venus, 1863,
Musée d'Orsay, Paris.
The classical style of
this work ensured a
good reception at
the Salon of 1863.

■ Jean-Francois Mlllet,
The Gleaners, 1858,
Museum of Fine Arts,
Boston. Millet was
among the first artists
in the group to portray
workers, imbuing
these figures with a
monumental dignity.

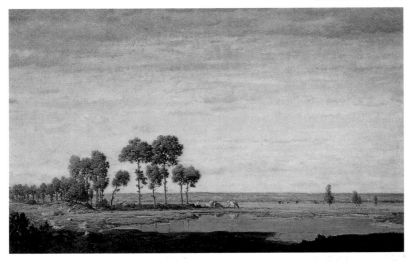

■ Théodore Rousseau,
*A Path Through the
Forest of L'Isle-Adam*,
1849, Musée d'Orsay,
Paris. Regularly excluded
from the Paris Salon,
Courbet applied himself
to studying nature from
life, and established
important aesthetic rules.

■ Heliostat signed
by J.C. Silbermann,
produced in Paris
in c.1850, Whipple
Museum of the History
of Science, Cambridge.

11

Caricatures

These examples are some of the few dozen surviving caricatures out of the many Monet produced during his school years at Le Havre: the four shown here are housed in the Musée Marmottan in Paris. The technique is a mixture of pencil and watercolor.

■ *Woman in a Madras Kerchief*, 1857. Not everyone is aware that the young Oscar (which is the name he used to sign his works until 1862) had carved out something of a reputation as a caricaturist beyond the narrow circle of his schoolfriends. Having seen how successful he was with his friends, he turned his passion for drawing into a lucrative activity. The delightful pictures included here are not just simple little portraits, but shrewd, exaggerated, and witty portrayals of human characteristics, justifiably regarded as a contribution to the development of French satirical art, which boasted many illustrious exponents such as Daumier. This ungainly drawing of a woman would have appealed to Leonardo da Vinci, the master of physiognomy. Her little madras cotton kerchief does her no service, other than to give her a hint of exoticism. It was a garment commonly worn by the citizens of Le Havre.

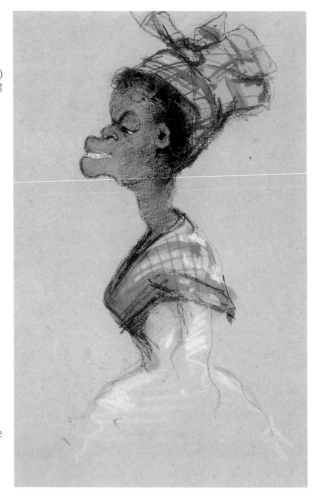

■ *A Little Theatrical Pantheon*, 1860. The actors Grassot, Leclère, and Got, the scriptwriter Lurine, and the actress Brohan form a fine group at which to poke fun. Pictures of famous people such as these often appeared in newspapers, while journalistic photographs, such as those by Nadar, were also becoming important. Monet would often base his work on them.

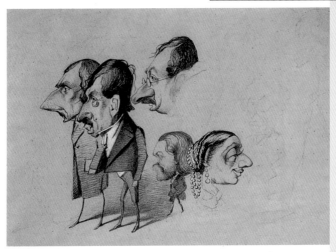

■ *Jules Francois Fleury-Husson*, 1858. Known as Champfleury, this famous novelist and art critic (c.1821–89) featured regularly on the Parisian cultural scene at this time. A mid-century bohemian, he was one of the first advocates of realism in art, supporting Delacroix and the landscape artists at the 1846 Salon and Daumier at the Salon of 1848. A friend of Courbet, he wrote a series of books on caricature between 1865 and 1880. Champfleury put forward a new aim for literature – the sharp observation of everyday life and human psychology.

■ *Man with a Straw Boater*, 1857. This ridiculous, foppishly dressed Parisian is ready for a seaside walk and a close look at the latest beach fashions. Through these interesting caricatures, Monet can be regarded as a sharp and adept creator of satirical art.

New ideas in an industrial Europe

The 1840s opened with the early signs of a cholera epidemic, a poor reflection of what had been a pioneering medical profession. The decade was characterized by many sensational events, including the international convention on the abolition of the slave trade in Europe, signed in December 1841. Balzac began writing the *Comédie humaine* cycle of novels, while another genius, Giuseppe Verdi, was also becoming famous. Architecture was transformed by new materials, such as iron and alloys, and the great exhibitions were mounted (the first in London in 1851). At this time, the idea of utilitarian art also took hold: the first exponents of this were the English Pre-Raphaelites, generally regarded as the forerunners of modern design. They revived medieval artistic and craft techniques, and virtually re-invented the concept of the all-round artist.

■ Camillo Cavour was a major political figure in the unification of Italy.

■ Left: This proof of *Les Fleurs du Mal* by Baudelaire shows the dedication to Théophile Gautier.

■ This photograph shows one of the stores of the enormous food market in the centre of Paris known as Les Halles (built from 1854).

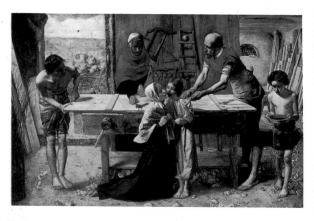

■ John Everett Millais, *Christ in the House of His Parents*, 1850, Tate Gallery, London.

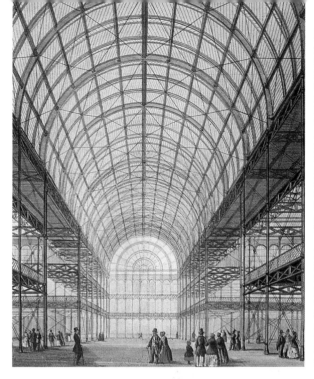

■ The Crystal Palace, home of the Great Exhibition of 1851, was an extraordinary building of iron and glass. Designed by Joseph Paxton, it was the result of extensive experimentation into how new industrial materials could lend themselves to architecture. Also dating from this time are the glass houses at Kew Gardens (1847).

■ Below, right: The philosopher Auguste Comte, father of positivism, published his essays *System of Positive Politics* and *Positivist Cathechism* by 1854, having already caused an uproar with his "Course of Positive Philosophy".

■ Left: Jean-Francois Millet, *The Angelus*, 1858–59, Musée d'Orsay, Paris. This work portrays a solemn moment of prayer in the middle of the day's work.

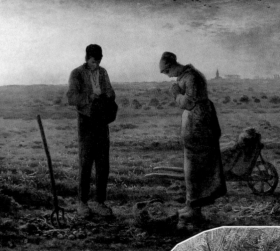

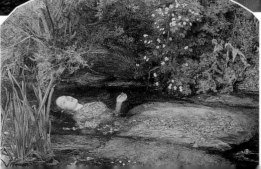

■ John Everett Millais, *Ophelia*, 1852, Tate Gallery, London. The idealized figure of the beautiful Shakespearean heroine also provided an opportunity for naturalistic observation.

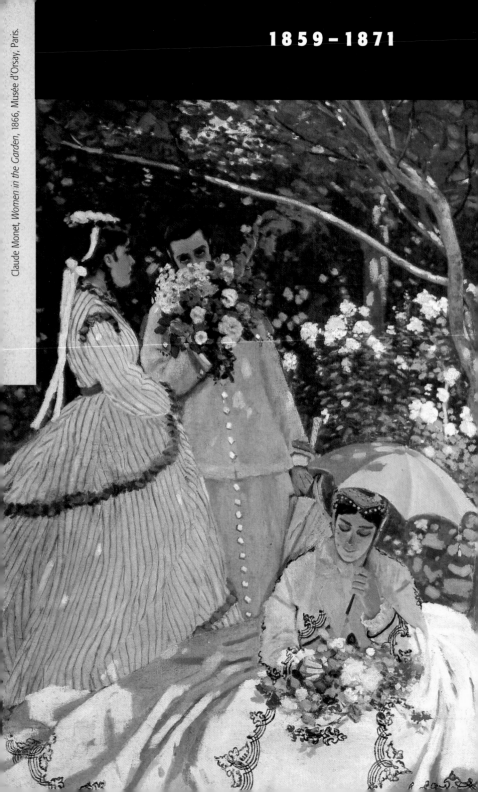

Claude Monet, *Women in the Garden*, 1866, Musée d'Orsay, Paris.

LIFE AND WORKS

The young artist

In January 1857, the young Monet lost his mother – the only person in the family who shared his interest in art. From then on, he was cared for by Jeanne-Marguerite Lecadre, an adopted aunt and amateur painter, who put him in touch with Armand Gautier, a close friend of Courbet. Despite being refused a bursary to study in Paris by the town of Le Havre, Monet decided to go to the capital anyway. He visited the Salon and showed his work to Gautier and Troyon, who advised him to study under Thomas Couture, an influential academic and sometime teacher of Manet. He was not interested in this suggestion, however, his artistic taste having by now been molded in the manner of Boudin, and his favorite artists among those exhibiting at the Salon were the naturalists Daubigny, Rousseau, and Corot. Delacroix he criticized for the excessively "unfinished" quality of his work. He began to attend the Académie Suisse, a shared painter's studio where he met Pissarro. He also began to frequent the Brasserie des Martyrs, the haunt of a group of young artists and writers. On June 10, 1861, he set off for Algeria to do his military service, returning a few months later on sick leave. As he would later comment, the North African light and landscape he experienced during that brief time were a preparation for Impressionism.

■ Claude Monet in the uniform of the Chasseurs d'Afrique. Photograph by C.M. Thuiller, Musée Marmottan, Paris.

■ Below left: Claude Monet, *Landscape*, Private Collection, Rome. In his country landscapes (this is one of many from his early period), Monet's colors were determined by the effects of the light, which created strong areas of contrast.

■ Right: Eugène Boudin, *The Beach at Trouville*, 1864, Musée d'Orsay, Paris. Delicate in effect but strong in touch, this style is very similar to Monet's early work. The light brushstrokes are typical of painting outdoors, faithfully reproducing the scene despite the swiftness of their execution.

■ Johann Barthold Jongkind, *The Seine and Notre-Dame de Paris*, 1864, Musée d'Orsay, Paris. The vibrant, pervasive light of the painting is extraordinary. The minute brushstrokes reproduce the sensation of freshness and airiness and the artist took particular care over the slightest atmospheric nuance.

Courbet, the giant of Realism

Gustave Courbet (1819–77), rejected for inclusion in the Paris Exposition Universelle of 1855, organized a parallel exhibition where he showed *The Artist's Studio* (1854–55, Musée d'Orsay, Paris). This provoked fierce criticism from the Academicians but became a milestone in Realism.

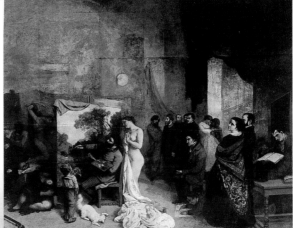

Conflicting ideas

■ Schopenhauer; one of the major philosophers of the 19th century.

Change and conflict swept through Europe in the 1870s. While the *pompier* style dominated private building designs, the new architecture of the cities consisted of bold, imposing iron structures and other manifestations of the industrial revolution. Philosophical debate concerned the unconscious, the rational, and the nature of freedom, explored in depth by, among others, the German Arthur Schopenhauer. The uprisings of the mid-19th century had affected all of continental Europe; and along with the new ideas of Romanticism had led to a general desire for justice and democracy. In Italy, for example, there was a clear desire for political and cultural change. In Florence, a group of young artists were active from 1855, who would be given the name *Macchiaioli*, from the painterly style they adopted: this was one of the earliest groups of Realist painters in Europe, working within a country which was in the process of becoming a unified nation.

■ The grand staircase, with a double curvilinear banister, in the Château de Ferrières (Paris) was built by Joseph Paxton for the Rothschild family in 1859. This copy of 18th century designs remained within the *pompier* style.

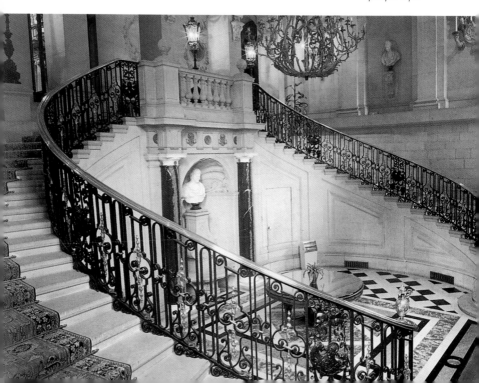

■ *The Interior of the Caffè Michelangelo*, c.1860, location unknown. In this watercolor by Adriano Cecioni, his debating companions are portrayed as grotesque caricatures. Among the other members of the first Italian Realist group were Borrani, Sernesi, Banti, Fattori, Lega, and De Tivoli.

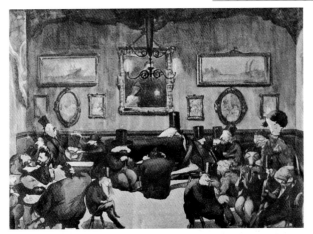

■ Telemaco Signorini, *The Florence Ghetto*, 1883, Galleria Nazionale d'Arte Moderna, Rome.

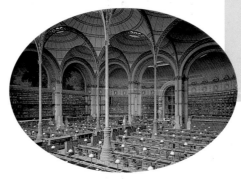

■ The reading room, Bibliothèque Nationale, Paris, 1859–68.

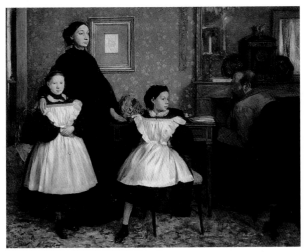

■ Edgar Degas, *The Bellelli Family*, 1860, Musée d'Orsay, Paris. Degas had met the *Macchiaioli* in Florence in 1858 and studies dating from this time led him to execute this splendid painting. The scene of domestic realism is characterized by a strong, lively lighting and clear, skilfully drawn outlines.

1859–1871

Studio Corner

This work, painted in Paris in 1861, is now housed in the Musée d'Orsay. It was one of Monet's first successful attempts at copying the style of French Realist painting.

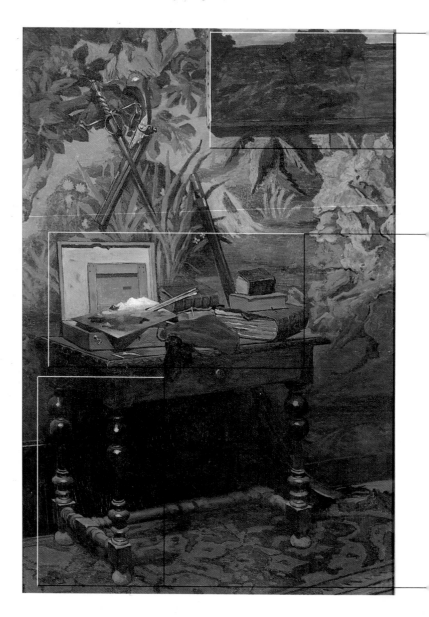

■ Landscape painting influenced Monet's formative years as an artist. Here, he chooses a reddish landscape for the detailed painting within a painting, often a difficult device.

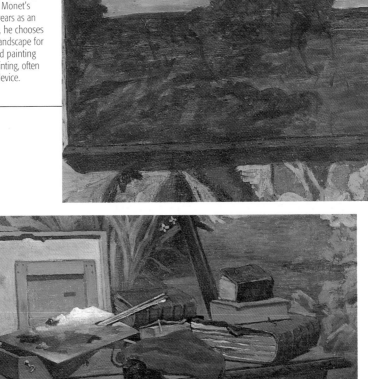

■ It is interesting to note how much care the young Monet gives to the paintbox, his palette, and his books and how he attempts to convey the texture and appearance of paint that has just been squeezed from the tube. This sense of immediacy is a constant feature in his work, although Monet, who never considered his canvases to be finished, often reworked parts of them.

■ The entire lower section of this large canvas (which measures 182 x 127 cm [71 x 49 in]) is in shadow: the table legs, in all their painstakingly reproduced and delicately brightened by a touch of white lead.

BACKGROUND

The scandalous Manet

■ Below: Giovanni Fattori, *Market at San Gaudenzio*, 1886–87, Galleria d'Arte Moderna, Florence.

■ Centre: Serfdom was abolished in Russia in March 1861.

These were the years in which the young Claude was finding his style. Others, however, were more than aware of theirs: among them was the Parisian Edouard Manet (1832–83), the artist to whom Monet seems to have most identified with at the time. Having opened a studio in 1856, Manet challenged the Academy when he exhibited *Le Déjeuner sur l'Herbe* in 1863, considered scandalous because the nude portrayed was not a model posing as a Greek goddess, but a young contemporary woman posing as herself. Manet revealed an even greater realism in *Olympia* (the beautiful model was a friend of Baudelaire's), painted in the same year and submitted to the Salon of 1865. He was harshly criticized for both the daring subject-matter and the technique, which consisted of the application of large *taches* (patches) of pure color, freely applied and arranged according to their tonal values in order to make the figures and objects even more and lifelike. At the same time, one of the most successful books of the century, *Les Misérables* by Victor Hugo, was published in Paris in 1862. Tolstoy was writing *War and Peace*, which was published after 1867. The principles of color harmony, developed by Chevreul, also gained in popularity at this time.

■ Edouard Manet, *Olympia*, 1863, Musée d'Orsay, Paris. This painting, which was also rejected by the Salon, was a milestone on the road towards a new style and a new realism.

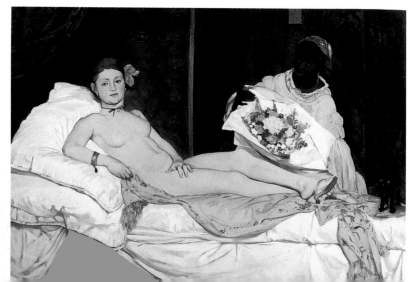

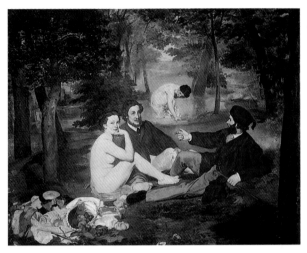

■ This photograph, dating from about 1860, shows a roped climbing party on Mont Blanc. The 19th century saw the growth of mountaineering as a challenging new sport.

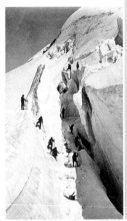

■ Edouard Manet, *Le Déjeuner sur l'Herbe*, 1863, Musée d'Orsay, Paris. This "improper" (as Napoleon III described it) but brilliant work is a keystone in the development of European painting. The naturalistic portrayal of the intimate group went against the theories of the Academy. The vivid use of color has its roots in 16th-century art, but painting had come a long way since Titian's *Country Concert*. There is no preparatory drawing behind the painting, and the background color is applied sparingly, with tonal contrasts.

■ William Morris, *Queen Guinevere,* 1858, Tate Gallery, London. This is one of the few paintings by Morris, remembered as one of the first true designers.

■ Eugène Delacroix died in 1863. With Géricault, he was one of the most innovative artists of the early 19th century. His stylistic freedom, regarded as excessive by some, did much to contribute to a change in taste and sensibility.

■ Honoré Daumier, *The Washerwoman*, 1863, Musée d'Orsay, Paris. This work is a well-known masterpiece from Daumier's later period, when he often painted popular themes. He was an extraordinary master of observation.

From Gleyre to the Salon

Exonerated from military service thanks to his aunt Jeanne-Marguerite, who paid the large sum required to buy him out, Claude was introduced by the genre painter Auguste-Claude Toulmouche to the studio of Charles Gleyre. This famous painter of historical scenes had developed a highly personal style and was admired for the meticulousness of his craft. In his studio, Monet met Bazille, Renoir, and Sisley. In the spring of 1863, Monet and his friends travelled to the area around Barbizon, which gave its name to the famous group of nature painters, and remained there until May. In early 1864, he made the acquaintance of a young medical student who, like him, would later find fame: Georges Clemenceau. That year, Gleyre's studio closed: Monet and the other artists left, at odds with the master's insistence on the aesthetic ideals of classical beauty. They remained faithful to the natural subjects they had explored during that period. Monet stayed at the coastal resort of Honfleur until the autumn, working mostly in the open air with Boudin and Johann Barthold Jongkind, the Dutch artist. His relationship with his father came under strain: Claude disappointed him bitterly by deciding to become a professional artist. After the May Salon, he began to be mentioned in the city's newspapers and became even better known after the Salon of 1866 – although his financial situation was grave. By then, he had met Camille, his first love.

■ Claude Monet, *The Bodmer Oak, Fontainebleau Forest*, 1865, The Metropolitan Museum of Art, New York. The palette is so lively here that the forest seems magical and alive, the light bursting between the branches and marking out the ground.

■ Claude Monet, *Beaching a Boat*, 1864, Memorial Art Gallery, University of Rochester, New York.

■ Claude Monet, *Camille* or *the Woman in the Green Dress*, 1866, Kunsthalle, Bremen.

■ This postcard of Honfleur is from 1864. The resort was visited by the Pointillists, including Paul Signac, who painted it in sunny, metaphysical works.

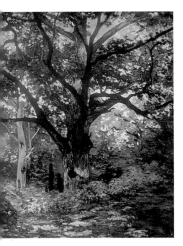

■ Taken in 1864 by Étienne Cariat, this snapshot of Monet shows the artist in a proud, resolute pose.

■ Alfred Sisley (1839–99) was one of the most active members of the group.

■ Pierre-Auguste Renoir (1841–1919) was one of the greatest painters of the 19th century.

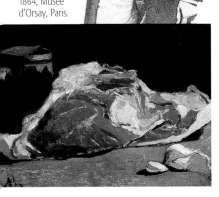

■ Claude Monet, *Women in the Garden*, 1966, Musée d'Orsay, Paris. This work is one of the masterpieces from the artist's early period,

while he was still influenced by the realism of the mid-19th century. The combination of color and light effects is painstakingly achieved.

■ Below: Claude Monet, *Still Life: Piece of Beef*, 1864, Musée d'Orsay, Paris.

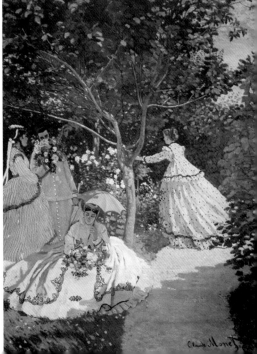

A tumultuous decade

The 1860s were significant years in Monet's life, and also in world history. The Civil War raged in the United States, and the Republican Abraham Lincoln was unexpectedly elected president, submitting a programme that focused on two issues: the strengthening of the welfare system and the abolition of slavery. The Southern states viewed the latter as disastrous for their economy, which was based on the exploitation of slave labor: this led to their desire for autonomy as the only way to maintain the status quo. Several other rebellions were prevalent in Europe at this time, not as violent but equally as radical: among these were the Milanese *scapigliati* artists, who after 1858 controversially broke away from the Italian artistic establishment. In 1861, Italy was unified into one nation, with Florence as its provisional capital. In literature, masterpieces such as *Our Mutual Friend* by Charles Dickens (1864–65), *Crime and Punishment* by Feodor Dostoevsky (1866), and *Thérèse Raquin* by Emile Zola (1867) appeared.

■ Top: after 1860, the waltz became an extremely popular dance: *The Blue Danube* by Johann Strauss the Younger was a great favorite.

■ Above: fashion plates were widely circulated as both drawings and photographs, and they provided useful reference for artists.

■ The *Great Eastern* was the largest ship in the world when it was launched in 1857. It laid the first transatlantic telegraph cables.

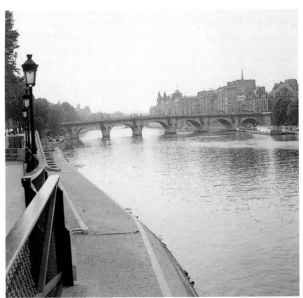

■ The Pont-Neuf in Paris is the oldest bridge over the Seine. King Henry III laid the foundation stone in 1578 and Henry IV opened it in 1606. For a long time it was at the heart of the city's social life, with theatre and dance performances held there from time to time.

■ Below: Edouard Manet, *Émile Zola*, 1868, Musée d'Orsay, Paris. Zola was one of the most important literary and intellectual figures in modern Europe. He painted a vivid picture of French society under the Second Republic in his novels, which included *Nana* and *Germinal*.

■ Below right: The influence of photography on painting was immense. It was thanks to photography that many artists attempted to reproduce reality as accurately as possible.

■ Pictured here is Mouret's cosmographic pendulum. The astronomical clock gives the solar time with the motion of the sphere, and the standard time through the movement of the clock's mechanism. It was patented in 1865.

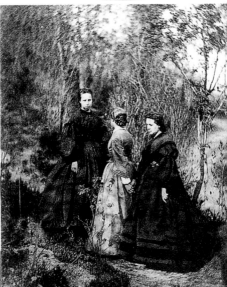

Le Déjeuner sur l'Herbe

This large canvas – 130 x 181 cm (51 x 71 in) – in the Pushkin Museum in Moscow was painted in 1865–66. It was either a study for the version in the Musée d'Orsay (of which only two fragments survive) or an independent, smaller version.

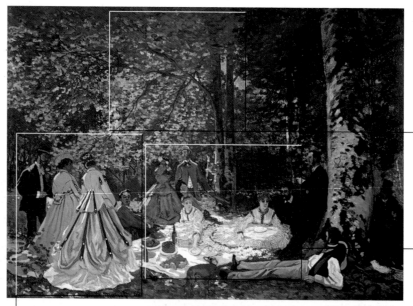

■ These elegant young ladies of the bourgeoisie are not as brazen as Manet's naked Parisian beauty. Monet may even have deliberately covered them in voluminous clothes to ingratiate himself with the Salon's selection committee. Camille may have been the only female model, placed in different positions.

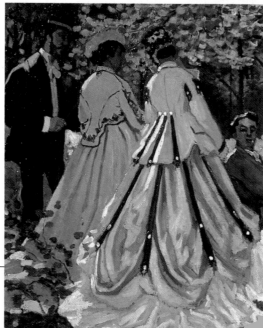

■ All the outdoor subjects painted by Monet in the early 1860s are present in this elaborate evocation of nature. The painting may have been a preparatory study executed *en plein air*, to be used as a model for the work to be carried out in the studio. The yellows (Monet used chrome yellow and lemon yellow) are irregularly added to the greens. Equally irregular is the reflection of the sun on the birch leaves.

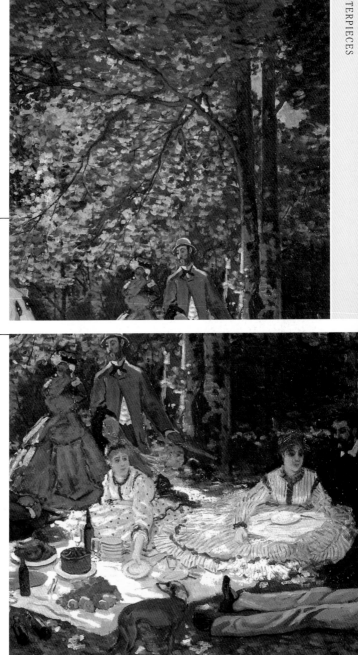

■ The allusion to Manet's eponymous work is clear. Despite admiring him, Monet sought to outdo his colleague by positioning 12 life-sized figures on a large canvas. Camille and Monet's friend Bazille posed for many hours in a forest clearing, so this painting has none of the studio technique that Manet adopted for his controversial work. The light focuses on the tablecloth and summer clothes, but also illuminates the rest of the scene, evoking beautifully the cool, restful shade.

Mixed fortunes

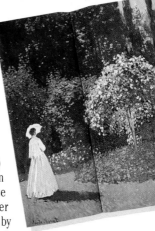

The relatively cool critical reception of *Camille* (or *The Woman in the Green Dress*) only worsened Monet's financial situation at the time. In order to escape from his creditors, who wanted to seize his works, Monet destroyed 200 of his canvases. A further blow came with *Women in the Garden* being turned down by the Salon of 1867. Leaving Camille, who was pregnant, in Paris he went to Sainte-Adresse where he would be sure of an income, and continued working on landscapes. Here, he contracted an eye infection, so serious that his physician advised him against being in the open air for long periods. His son Jean was born on August 8 and the family moved to Le Havre; however, Claude's precarious finances were a source of despair and he later confessed to his friend Bazille that he had tried to drown himself. He continued painting at a frenzied pace: the collector Louis-Joachim Gaudibert commissioned a series of family portraits from him, and *The Woman in the Green Dress* was purchased by the periodical *L'Artiste* at the International Maritime Exhibition in Le Havre. At the end of this show, four of his paintings were seized by creditors, but immediately bought by his friend Gaudibert. The Monets then moved to Etretat, where Courbet had once stayed. Despite his financial uncertainties, Claude remained deeply committed to his art.

■ Claude Monet, *Jeanne-Marguerite Lecadre in the Garden*, 1867, The State Hermitage Museum, St. Petersburg.

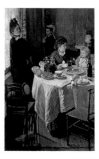

■ Above: Claude Monet, *The Luncheon*, 1868, Städelsches Kunstinstitut, Frankfurt. This picture of domestic intimacy was also rejected by the Salon.

■ Left: Claude Monet, *Saint-Germain l'Auxerrois*, 1866, Staatliche Museen, Berlin. Vibrant and colorful, this famous painting demonstrates the artist's growing confidence in his style.

■ Claude Monet, *The River* or *The Seine at Bennecourt*, 1868, The Art Institute of Chicago.

■ Claude Monet, *Terrace at Saint-Adresse*, 1867, The Metropolitan Museum of Art, New York. Slightly schematic in structure, this early work includes the classic Monet themes of flowers and water. It signals an effort by the artist to detach himself from the Realist influence, making his palette more luminous.

The old gentleman seated in the foreground is the artist's father.

■ Claude Monet, *Portrait of Mme Gaudibert*, 1868, Musée d'Orsay, Paris.

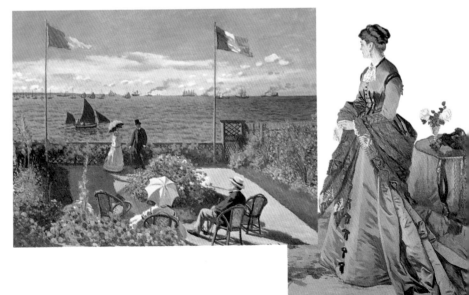

Innovations and exhibitions

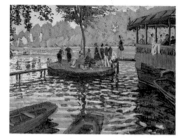

■ Claude Monet, *La Grenouillère*, 1869, The Metropolitan Museum of Art, New York. Bathers from the middle classes are pictured enjoying leisure time.

The 1860s were overshadowed by momentous events: several eminent figures in European culture died, including Baudelaire, who had been a fervent admirer of the new art, as practiced by the group known as *la bande à Manet*. International politics were shaken by major developments: in 1866, the United States granted political rights to its black population, and, in 1869, the British Liberal William Gladstone became Prime Minister, ousting the Conservative party, which had the support of Queen Victoria. Young artists in Paris – the aesthetic barometer for France as a whole – could from 1863 participate in a new Salon, opened by Napoleon III and known as *Salon des Refusés*. At its first show no fewer than 4,000 works were exhibited, all of which had been turned down by the official annual Salon held by the Beaux-Arts. A further element of innovation lay in its inclusion of a large amount of Japanese graphic art – popular with many for its powerful two-dimensionality and aesthetic sense – at the Exposition Universelle of 1867.

■ Frédéric Bazille, *Family Reunion*, 1867, Musée d'Orsay, Paris. A blend of psychological insight and painterly skill is shown here.

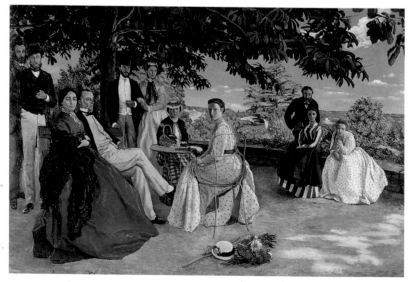

The Great Exhibitions

These works were part of the Exposition Universelle, held in Paris in 1867. After those in London and New York, the third and fourth exhibitions took place in Paris amid much press coverage and popularity. Artists who usually only exhibited two works at each annual Salon could here show a much wider range of work. The exhibitions also provided an opportunity to view foreign works, which often encouraged change in local, traditional artists.

■ Berthe Morisot, *The Cradle*, 1872, Musée d'Orsay, Paris.

■ Berthe Morisot (1841–95) was a pupil of Corot and Manet. She took part in the group's first exhibition with her work *The Cradle*.

■ The column in Place Vendôme, Paris, which was erected in 1810 in honor of Napoleon I. The continuous frieze tells of the emperor's exploits. The column was demolished in 1871, but later restored.

1859–1871

Women in the Garden

This work, now in the Musée d'Orsay, was painted in 1866. Despite the slightly staged manner of the figures and the strange perspective, it is one of Monet's masterpieces from his early period.

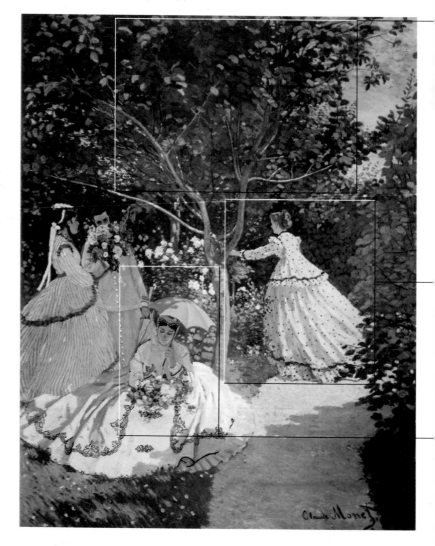

■ The foliage is painted in greens and browns, with a few touches of black, and is built up in layers. The progression of shades helps achieve the effect of the leaves shimmering in the delicate sunlight.

■ The work was probably painted entirely in the open (contrary to Manet's practice, which was to spend long working sessions in the studio), with a few dry-color touch-ups. Courbet visited Monet at his house to see the work, but was rather critical. The figures have no real relationship to one another (once again, it was Camille who posed for all of them), and this lack of narrative appealed neither to Courbet nor the selection committee of the 1867 Salon, who rejected the work.

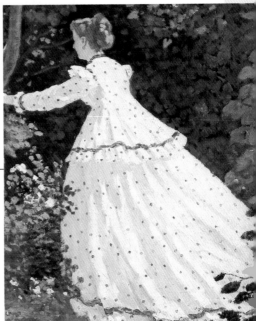

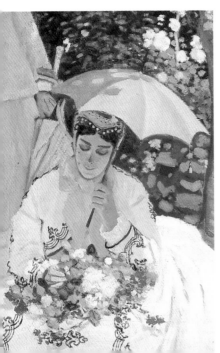

■ In an article written in May 1868, Émile Zola described the light muslin gowns in this painting as blindingly white, and that the relationship between light and shade produced an odd effect. The dominant white is very strong (even when mixed with mauve in the shaded areas), producing shapes that are so vivid that they appear almost unreal. Monet paid particular attention to the details of his figures' clothes.

The daily pursuit of perfection

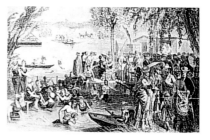

■ This drawing by Fernando Miranda y Casellas (1842–1925) brings vividly to life the joyful atmosphere of La Grenouillère, a popular bathing resort on the Seine, with a well-known restaurant named after a nearby pond full of frogs. Here, Monet and Renoir would work side by side.

Monet was attempting to perfect his individual style of painting as the 1860s progressed, experimenting with brushwork to obtain his desired effect. At his house in Saint-Michel, on the outskirts of Paris, the artist was often visited by his friend Renoir and their regular meetings inspired both artists to grow and develop. The subjects they chose were frequently the same, and they shared a common interest in the effects of light on the surface of objects. There was no competition between them, but rather a genuine sharing of ideas and feelings that led them simultaneously towards areas of experimentation. Monet and Camille were married on June 18, 1870, in the presence of just a few witnesses, including Courbet. Their happiness was overshadowed by France declaring war on Prussia on July 19. The couple moved to London, since Great Britain was neutral. Here Monet grew close to Pissarro, sharing his admiration for British artists, especially Turner and Constable, whose influence on the young French colorists is undeniable.

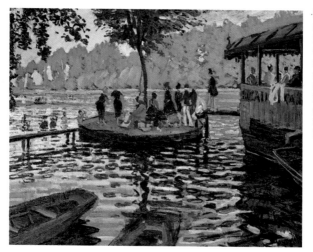

■ Claude Monet, *La Grenouillère*, 1869, Metropolitan Museum of Art, New York. This celebrated work, rightly admired for the quality of the reflection of the light on the water, can be considered the first totally Impressionist painting.

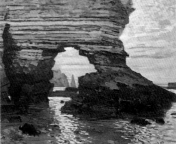

■ Here, Paul Durand-Ruel, the first gallery owner to support the Impressionists, is pictured in a photograph taken in about 1870. His relationship with the temperamental Monet was often strained.

■ Claude Monet, *Houses on the Zaan River*, 1871, Musée d'Orsay, Paris. The bright northern light obviously inspired Monet's palette.

■ Claude Monet, *The Thames and the Houses of Parliament*, 1871, Tate Gallery, London. Monet painted many pictures of the River Thames and its surrounds. The influence of Turner, whose work Monet had seen at the Tate Gallery, is clear.

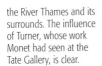

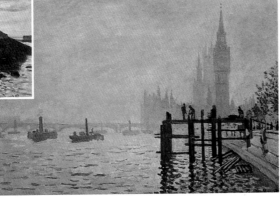

■ Claude Monet, *Cliffs at Etretat*, 1868–69, Fogg Art Museum, Cambridge (Mass.). The theme of water and the effects of light on its surface was a perennial favorite with Monet.

War and revolt

■ Silver goblet in the shape of a Roman galley with allegorical figures, by the Parisian brothers Fannière (1869).

I n 1871, Paris endured one of the most tumultuous and violent periods of its history. Following the defeat of France and the collapse of the Second Empire, the insurrection of the dissaffected residents of Paris led to the establishment of the Paris Commune. The suppression of the Commune by government troops culminated in the "Bloody Week" of May, when about 20,000 insurrectionists were killed. Bazille, Degas, Renoir, and Manet enlisted, while Cézanne returned to his native south and Monet, a Republican, joined his friends Pissarro, Sisley, and Daubigny in London. The bloodshed did not deter those who wanted radical reforms in national politics and calls for change were still made. Even those who felt the need for drastic changes within the world of art had their convictions strengthened by the experiences of Paris. The artists gathered together from 1872, fully prepared to put up a fight in order to bring about the changes they wanted. Further afield, meanwhile, the Metropolitan Museum of Art was founded in New York, destined in just a few short years to become a formidable rival for the major European collections. Everywhere in the world there was a sense of unrest, and an urgent need for change and improvement in many areas of life.

■ Rue de Rivoli after the "Bloody Week" of 1871.

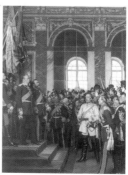

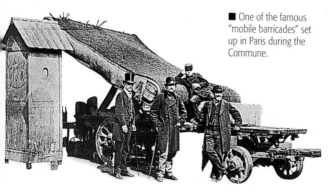

■ One of the famous "mobile barricades" set up in Paris during the Commune.

■ One of the most important engineering feats in the world, the Suez Canal opened in 1869. Planned by the Frenchman Ferdinand de Lesseps, it was started in 1859 using Egyptian labor. The cost was 505 million francs. During the lengthy excavations, a total of 74 million cubic meters of sand and rock were dug up. From 1900, the canal saw a huge amount of traffic, often carrying massive loads.

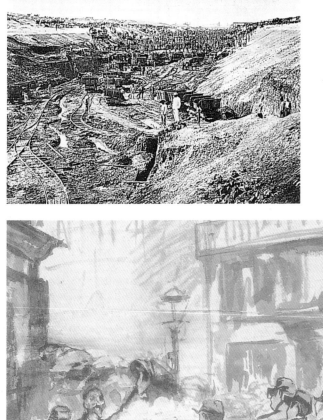

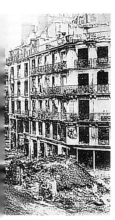

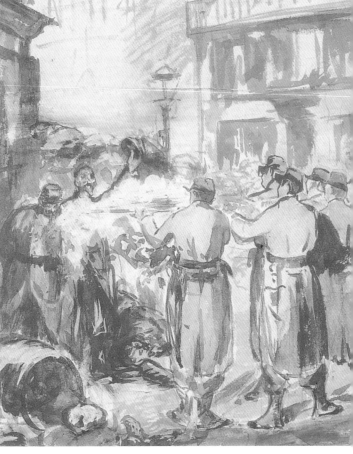

■ *Left:* William I of Prussia was pronounced emperor on January 18, 1871, at Versailles in the presence of 32 German princes. They also proclaimed the birth of the Reich.

■ *Right:* Edouard Manet, sketch for *Paris Barricade*, 1871, Pushkin Museum, Moscow.

MASTERPIECES

La Grenouillère

This work of 1869, painted in oils like its predecessors, is now housed in the Metropolitan Museum of Art, New York. It is one of many paintings devoted to the famous riverside resort near Bougival, where Monet lived and worked.

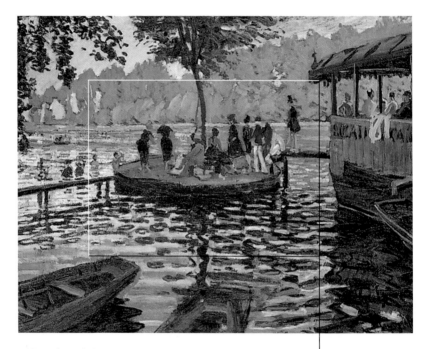

■ The work reveals the influence of Manet in the way in which the artist attempts faithfully to reproduce the effects of light. Blue, pink, ochre, and white are used to convey the gentle rippling of the water. The figures are reduced to tiny masses of coarsely applied color. Works such as this proved Monet's masterful skill in the rendering of natural beauty.

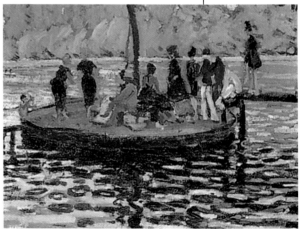

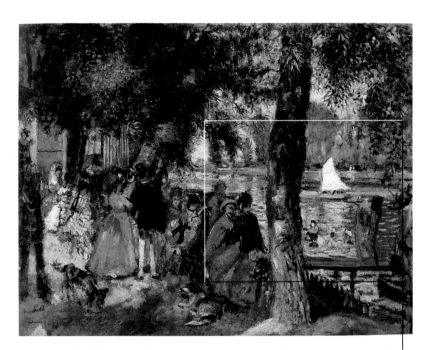

■ Renoir also painted many versions of this subject; shown here is *La Grenouillère*, 1869, Pushkin Museum, Moscow. The two artists attempted to represent the reflection of light on water in a similar way. Here, Renoir clearly outlines his objects and illuminates the fence, the tree trunk and the clothes with dabs of color.

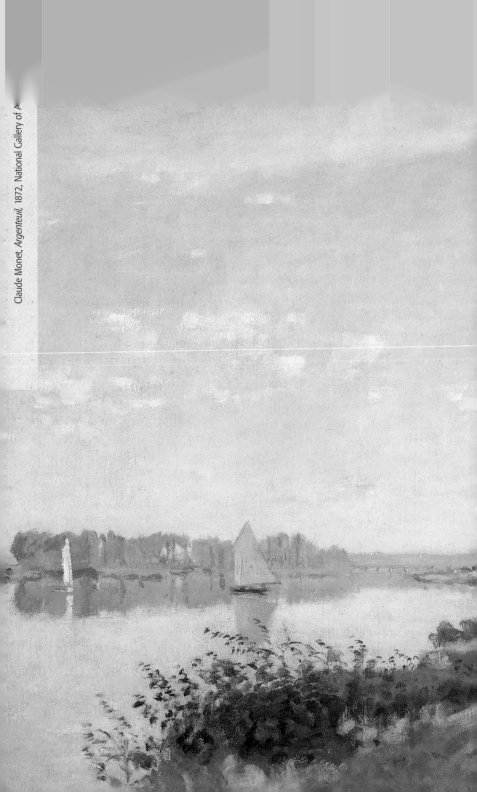

Stability and harmony

In December 1871, Monet moved to a house at Argenteuil, by the Seine. The little town and its surroundings provided the artist, now more confident of his own style, with many themes and subjects to paint over the next few years. His lifestyle improved, thanks to the gallery owner Paul Durand-Ruel purchasing 29 paintings from him for a total of almost 10,000 francs. From now on, Monet could lead a more economically stable life and concentrate on his work, which was increasingly following a particular style. He often painted Camille and Jean, and his new-found harmony enabled him to achieve some of the most extraordinary results in his work. He also bought a small boat – a floating studio – in order to be even closer to the water, which was an source of intense fascination to him. Thanks to Durand-Ruel, he became well-known in London and the seeds of his good fortune were slowly being sown. In response to the Salon's rejections, he formed a group with a few like-minded artists, known from December 1873 as the "Société Anonyme des Artistes Peintres, Sculpteurs, Graveurs, etc.". Among the artists involved were Renoir, Pissarro, and Cézanne – another artist of strong principles.

■ Claude Monet, *Jean Monet in the Home,* 1875, Musée d'Orsay, Paris. Here, Monet skilfully reproduces the complexity of interior light and shade on canvas.

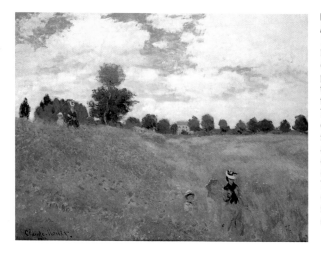

■ Claude Monet, *Poppies near Argenteuil,* 1873, Musée d'Orsay, Paris. This small painting (50 x 65 cm [19 x 25 in]) paradoxically evokes the wide expanse of the meadow and sky. The mothers and their children walk down the slope at a relaxed pace and the large clouds convey a pleasant feeling of freshness and space. This work would almost certainly have been shown at the famous exhibition of 1874.

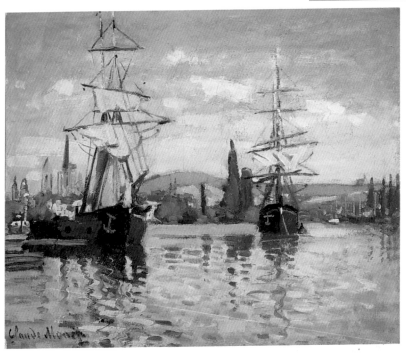

■ Claude Monet, *Boats Moored on the Seine at Rouen*, c.1873, National Gallery of Art, Washington, DC.

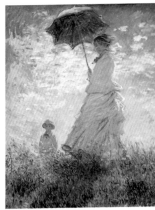

■ Claude Monet, *Lilac Tree in the Sun*, 1872, Pushkin Museum, Moscow. This small work is paired with the *Lilac Tree, Grey Day*, 1872, now in Paris. Monet's technique in oils and his sensitive treatment of color are highly developed here.

■ Claude Monet, *Woman with a Parasol – Mme Monet and her Son*, 1875, National Gallery of Art, Washington, DC.

BACKGROUND

The cities change

U pheavals were occurring in the arts and architecture throughout Europe. Among the masterpieces published at this time were *The Birth of Tragedy* by Nietzsche and *I Promesi sposi* by Alessandro Manzoni. Brahms composed his celebrated String Quartets, which were among the most important musical works of the 19th century. During the second half of the century, the historical centres of Europe's great capitals were restructured, including Paris and Vienna. Considerable sections of the city were sacrificed to a rigid system of town planning that rationalized space and function. The concept of the wide, scenic avenue dominated this vision, an open and bright thoroughfare, where road traffic was confined to controlled areas. This led to the creation of the Ringstrasse in Vienna, the circular road at the core of the city, and the birth of the great Boulevards in Paris.

■ Left: *Voyages Extraordinaires* by Jules Verne, one of the most popular authors of the 19th century, was published in 1873.

■ This map by J.C. Alphand shows Paris at the time of Baron Haussmann's restructuring (1853).

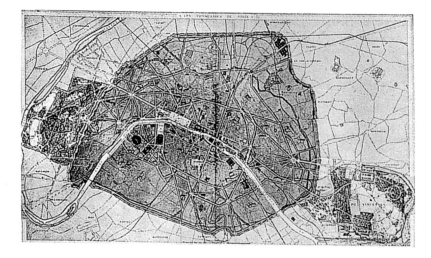

■ The grand staircase of the Paris Opéra, in an original drawing of 1872–75. The interior was decorated in a rather eclectic style.

Cézanne, the rebel

Paul Cézanne painted *The House of the Hanged Man* (above, Musée d'Orsay, Paris) in 1872 at Auvers-sur-Oise. Exhibited by Nadar in 1874, it embodies principles that are totally different from his earlier works. Cézanne never associated himself directly with the Impressionist school, preferring instead to pursue his own individual style.

■ Below: Paul Cézanne, *A Modern Olympia*, 1872–74, Musée d'Orsay, Paris. This work pays homage to Manet and his great masterpiece *Olympia*, celebrating him in an ironic but affectionate way.

■ Classical and decorative in style, Charles Garnier's Paris Opéra (1861–75) is the largest theatre of its kind in the world.

■ Alessandro Manzoni, author of the acclaimed *I Promessi sposi*, died in Milan in 1873.

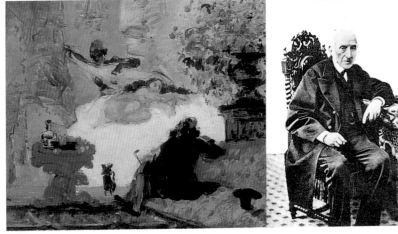

Impression, Sunrise

This small painting – 48 x 63.5 cm (18 x 24 in) – dating from 1873, is now in the Musée Marmottan, Paris, and has become one of Monet's best-known works. It shows the harbor at Le Havre in the stillness of daybreak.

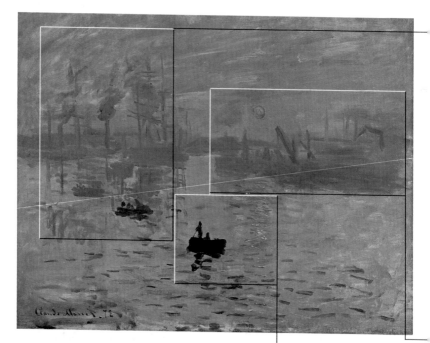

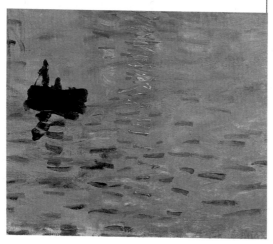

■ The work was shown at the group's first exhibition in 1874. Critics regarded the style of the painting as too indistinct, and gave it the pejorative name Impressionism, which the artists themselves later adopted. The dim, hazy twilight envelops the scene, except for the distinct shape of the boat in the foreground, which is a central perspectival element.

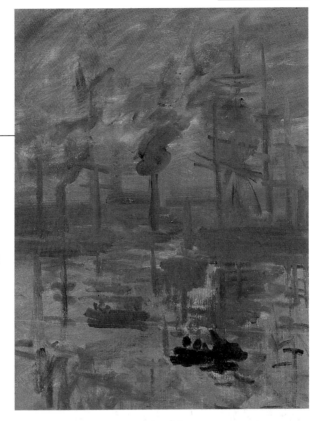

■ Monet did usually carry out preliminary work, which he referred to as his *pochades* or sketches, but he maintained that this painting was a true "impression" – a brief visual moment, not contrived or overworked. He probably produced the painting in a single sitting.

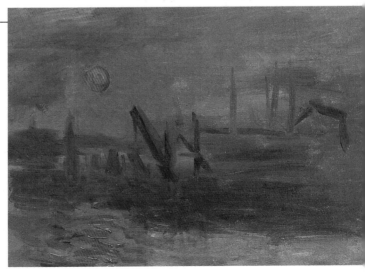

■ The orange of the sun reflects on the water and across the hazy sky. The sun's color is thick and rich, deepened by the addition of yellow and vermillion. During his recent journey to London, Monet had been very struck by the works of the English Romantics such as Turner and Whistler.

The birth of Impressionism

The upturn in Monet's finances was shortlived: in 1874, he was affected by the economic problems of the gallery where he often exhibited his work. In the spring of that year, however, the "Société Anonyme" mounted its first exhibition at the studio of the famous photographer, Nadar, showing no fewer than 165 works, including seven in pastel and five in oil by Monet. In a famous article written on April 25, Louis Leroy, the critic of the satirical periodical *Le Charivari*, defined the artists as "Impressionists", a term borrowed from the title of Monet's painting but used disparagingly to poke fun at the styles of this group of artists. It was following a second article, written a few days later by Castagnary, that the name stuck permanently. Monet could not financially make do with the few sales he made up until this time; keen to find buyers and to generate more interest, he organized an auction at the Hôtel Druot with Berthe Morisot, Renoir, and Sisley. The auction was controversial, and anti-Impressionist protests at the auction culminated in heated arguments and a minor disturbance – eventually the police were called to calm the situation.

■ *Courtesan Painting her Lips* is one of the Japanese artist Kitigawa Utamaro's most famous prints. Japanese works of art had been available for purchase in Paris since 1862.

■ Far left: Claude Monet, *La Japonaise*, 1876, Museum of Fine Arts, Boston. This painting, shown at the group's second exhibition, met with a favorable reception. Parisiens had become infatuated with Japanese art and many private collections were created.

■ Left: Kitigawa Utamaro (1754–1806) was the most celebrated artist of the Ukiyo-e ("pictures of the floating world") style.

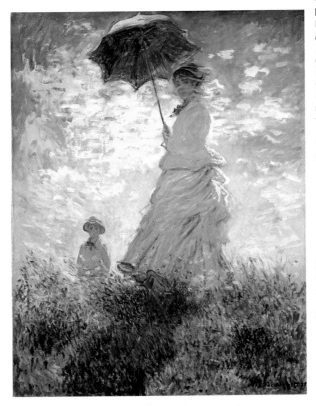

■ Claude Monet, *Woman with a Parasol – Mme Monet and her Son*, 1875, National Gallery of Art, Washington, DC. Painted four years before Camille's death, this was reworked as *Woman with a Parasol* almost 11 years later, with Monet's beloved step-daughter Suzanne Hoschédé as the model.

■ Below left: Claude Monet, *Rose Beds in the Hoschedés' Garden at Montgeron*, 1876, The State Hermitage Museum, St. Petersburg. This is one of four paintings commissioned by the textile merchant Ernest Hoschedé. This work dates from a time when Monet is believed to have begun a relationship with Hoschedé's young wife, Alice.

■ A photograph of the youthful Monet.

The Impressionist Group

The period that Monet spent at Argenteuil was the most inspired phase of his artistic career. Their first controversial exhibition was followed by another, *Exposition de peinture*, held at Durand-Ruel's gallery in 1876. Only 18 artists took part, instead of the 30 who participated in the first exhibition. They included Monet, Berthe Morisot, Sisley, Pissarro, and Renoir. Gustave Caillebotte, Monet's friend and supporter, was also an exhibitor, and his *Floor Planers* was widely admired for its extraordinary photographic quality. After this exhibition, *La nouvelle peinture* was published, an essay written by the critic Edmond Duranty, considered to be the most active and committed supporter of the young artists. Each artist was developing their own particular style, and in time they pursued different and sometimes conflicting directions. Cézanne at this time had already chosen his own highly individual path to follow.

■ Paul Cézanne (1839–1906) was born in Provence in the south of France. The rebel of the group, he explored ideas of a "parallel reality" in his art and was immensely popular with the avant-garde.

■ Nadar's studio in the boulevard des Capucines.

■ Alfred Sisley, *Flood at Port-Marly*, 1887, Musée d'Orsay, Paris. A close friend of Monet's, Sisley experimented with light and perception in his paintings of outdoor views. This work earned him a large sum.

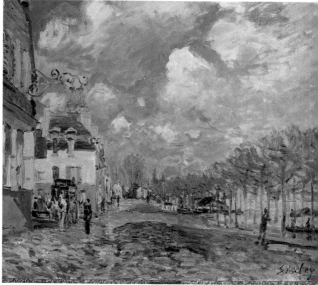

■ Camille Pissarro, *Red Roofs*, 1877, Musée d'Orsay, Paris. This splendid view of Pontoise demonstrates how Pissarro's Impressionist style differs from Monet's.

■ Berthe Morisot, *The Looking Glass*, 1876, Thyssen-Bornemisza Collection, Madrid. Morisot painted *en plein air*, favoring family subjects and developing a delicate, muted style.

■ Pierre-Auguste Renoir, *La Balançoire*, 1876, Musée d'Orsay, Paris. Renoir's female subjects are typically portrayed as delicate, poetic, and sweetly sensual figures.

■ Edgar Degas, *L'Absinthe*, 1876, Musée d'Orsay, Paris. Degas' skill is clearly illustrated in his evocative and melancholic portrait of a woman lost in an alcoholic stupor – and in her own thoughts.

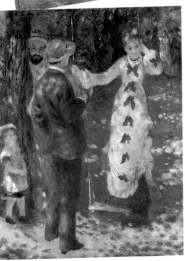

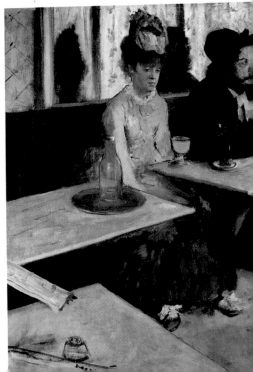

Bridge at Argenteuil, Grey Day

Painted in 1876, this work is now in the National Gallery of Art, Washington, DC. It is one of many splendid paintings by Monet of this famous iron bridge across the Seine, which was rebuilt after the Franco-Prussian War.

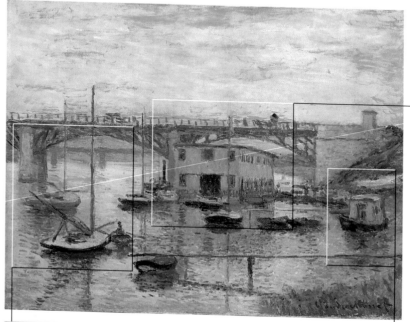

■ In other works, the bridge is the sole focus of the composition, but here Monet explores the surrounding scene, including the houseboats and other vessels. An air of calm and stillness pervades the scene, with little movement either on the river or on the bridge. The gray light creates a slightly mysterious atmosphere. The small boat in the foreground is at rest, sail down, and next to it is a solitary figure in a rowing boat. The blacks and browns Monet uses here are muted and well-balanced, and the more distant boat of the two is soft and blurred in the background. The overall feeling is one of tranquillity and peace.

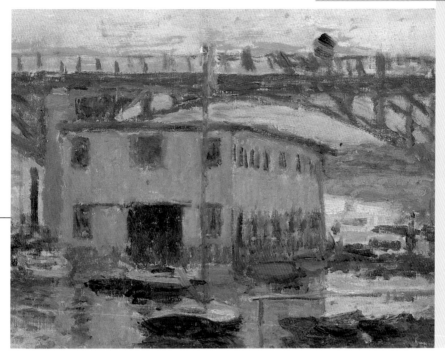

■ Monet felt it was very important to reproduce exactly what he saw as best he could. His treatment of the floating house at the center of the composition, painted in muted colors, is a good example of this. It is an integral part of the scene, the walls toned down to harmonize with the greyish patina that pervades their surroundings.

■ It was often Monet's practice to paint standing in a small boat (*botin*) on the water, which he had specially equipped for the purpose. This would have been a boat very similar to that shown here. Objects and reflections appeared appreciably different from the water than from the land and a view from the river enabled skilled artists to gain more of a direct feel for their subject. Monet's working method was a modern one and he ignored the traditional rules of the Academy (such as painting in the studio with a limited palette), as did others of his generation.

Success in adversity

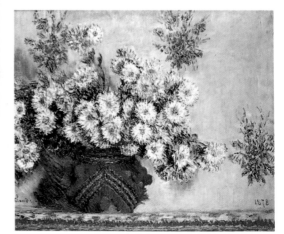

Visiting a friend who lived in the rue de Rivoli, Paris, Monet took the opportunity to paint the Tuileries gardens opposite. His was a delicate, powdery interpretation, in contrast with Pissarro's more detailed treatment and sharper, more precise technique. Thanks to his friend Caillebotte, who offered to pay his rent, Monet was able to move near the Gare Saint-Lazare, which he went on to capture in a series of memorable paintings. The works devoted to this famous Paris station are among Monet's finest and most interesting works. At this time, the third exhibition of the independent group of artists took place, who now defined themselves officially as Impressionists. He kept up his influential contacts, such as Ernest Hoschedé, who continued to collect his paintings. However, he worked amid great adversity: he was still under pressure from creditors in Argenteuil, which he had left for good in early 1878. And, although his second son, Michel, was born in March 1878, Camille became frail and ill shortly afterward – she was never to recover.

■ Top: the Durand-Ruel drawing room featured door panels by Monet and a Renoir on the wall.

■ Above: Durand-Ruel's gallery was situated in rue Le Peletier in the centre of Paris. He had begun his bold and visionary art collection in 1865.

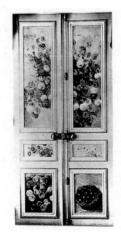

■ The door panels at Durand-Ruel's house were painted by Monet.

■ Right: Claude Monet, *Chrysanthemums*, 1878, Musée d'Orsay, Paris.

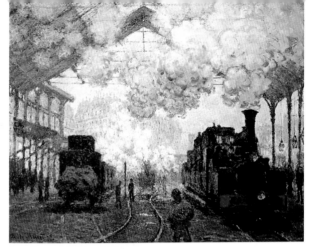

■ Claude Monet, *The Gare Saint-Lazare*, 1876–77, Fogg Art Museum, Cambridge, Mass.. In 1877, Monet was given permission to paint the interior of the station. It took up most of his time and energy that year, and he produced 12 canvases in all.

■ Claude Monet, *The Gare Saint-Lazare*, 1876–77, The Art Institute, Chicago. Monet showed seven versions of this scene at the 1877 exhibition.

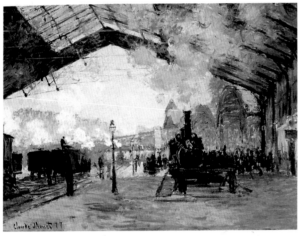

■ Below: Claude Monet, *Rue Montorgueil Decked out with Flags*, 1878, Musée des Beaux-Arts, Rouen. A celebration, in Monet's typical style, of the popularity enjoyed by Paris that year after the Exposition Universelle.

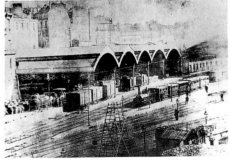

■ Pictured here is the Pont de l'Europe, built in about 1850, which overlooked the station that was so dear to Monet. The Gare Saint-Lazare served the great rail routes to and from Normandy. It was rebuilt in 1855–89.

An era of change

The year 1877 saw the death of Gustave Courbet, a consummate artist of the modern age who had exerted a profound influence on Monet. It also heralded the second sale of Impressionist works, held at the Hôtel Druot, and the third Impressionist exhibition, which took place at Durand-Ruel's gallery. Attended by a more favorable, discerning public, and by collectors who were becoming increasingly interested, this third show enjoyed press notices that were genuinely well-argued and not based merely on destructive criticism. The event revealed a strong, confident, diverse group that was professionally highly competent. Eighteen artists took part, each exhibiting several works: Sisley showed his beautiful *Flood at Port-Marly*, Renoir *The Dance at the Moulin de la Galette*, and Degas *L'Absinthe* (which depicted a very well-known interior, that of the Café de la Nouvelle Athènes, the new meeting-place of the Impressionists). Elsewhere, a number of major events took place during this period: military activity in the Balkans intensified, the Industrial Revolution was underway and many discoveries in engineering, chemistry, and technology were made at this time. In the worlds of music and literature, Tchaikovsky composed *Swan Lake* and Strindberg published his novel *The Red Room*.

■ Honoré Daumier died in 1879, one of the most acute observers of the society of his day, and a celebrated satirical draughtsman.

■ The year 1879 saw the Tay Bridge disaster in Scotland, when a train plunged from the bridge into the River Tay. The locomotive was successfully salvaged.

■ In January 1878, Leo Tolstoy's *Anna Karenina*, one of the literary masterpieces of the era, was published in Russia. It tells the story of a young Russian noblewoman trapped in a loveless marriage who has an affair with the young Count Vronsky and, finally, wracked with guilt, commits suicide by throwing herself under a train. Another great epic novel, *War and Peace*, had already enjoyed great success.

■ Right: crowned queen in 1837, Victoria (1819–1901) was a strong supporter of Prime Minister Disraeli's policy of imperialism. She became Empress of India in 1876. Her rigid morality, combined with her willingness to embrace progress, was to define the age.

■ Edgar Degas, *Little Dancer Aged Fourteen Years*, after 1878, Museu de Arte, Sao Paolo, Brazil. This elegant young dancer was a typical subject for Degas, who produced numerous studies of the female form in motion.

1872-1883

The Gare Saint-Lazare

Painted in 1877 and now in the Musée d'Orsay, Paris, this version of Monet's much-loved scene was created in oils. Although part of a series of 12 paintings, it stands alone as an expression of the vitality and frenzy of Parisien life.

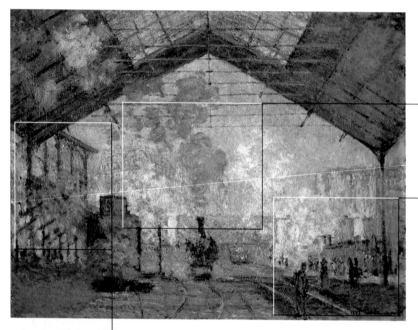

■ Railways and stations were at this time becoming an important part of everyday life, fundamental to the new industries, and one of the century's great spectacles. Here, the angular geometry of the station's metallic structure perfectly encapsulates the new technological age. Allthough also painted by Manet and Caillebotte, railway stations were not a subject frequently explored in Impressionist painting, which concentrated on natural phenomena or groups of people in outdoor scenes. For Monet, the station was the last theme he drew from contemporary human life, and after this series he devoted himself exclusively to nature painting.

■ At the heart of the composition, the locomotive belches blue fumes high up into the sky. Monet focuses on light and atmosphere: the sun lights up the whole picture, with touches of ochre and yellow. In subject and atmosphere, the painting is reminiscent of Turner's *Rain, Steam and Speed* (1844, National Gallery, London).

■ Monet was not against the use of black on principle. Here, he uses it in a radically different way from that recommended by the Academic tradition, blending it with other dark colors to emphasize the outline of the figures along the platform. These are painted in a loose, sketchy manner, with small touches of ochre suggesting the faces. Monet allows color to take over the whole canvas, using it build up form and volume, even with the intermediary shades such as mauve or pale yellow, long neglected in art. His irregular brushstrokes build up a thick yet delicate texture.

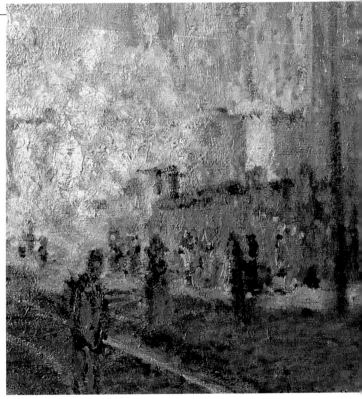

1872-1883

Sadness at Vétheuil

After much suffering, Camille died on the morning of September 5, 1879, at the age of just 32. She left Claude deeply depressed and "alone with my poor children". The family had only recently moved to Vétheuil and the artist had spent almost all his meager earnings on his wife's medical treatment. Caillebotte entered him for the fourth Impressionist exhibition: once all the sales were added up, each of the 16 artists was left with 439 francs. Monet then produced a series of still lifes, and the harsh winter weather prevented him from painting out in the open. He was able to sell some of these, which to an extent lifted him from his depression and gave him the strength to go on. In June 1880, he held his first one-man show at the offices of the periodical *La Vie Moderne* and sold a number of paintings. He dropped out of the Impressionist group's fifth exhibition, but built up a small, faithful clientèle at Vétheuil and turned once more to Durand-Ruel, who bought paintings regularly from him from 1881. The year 1882 was an intensely productive one for him. He travelled extensively along the Normandy coast, often finding inspiration at the beach of Varengeville. He mourned Camille, and his grief was reflected in his work. In April 1883, he moved to Giverny, in search of solitude and quiet.

■ This photograph shows Monet aged about 40. It was at this time that he became interested in producing works in series.

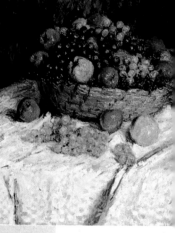

■ Seeking solace from his grief, Monet spent many days on the beach at Varengeville.

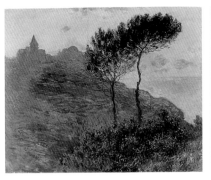

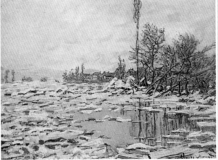

■ Claude Monet, *The Church at Varengeville, Cloudy Weather*, 1882, J.B. Speed Art Museum, Louisville. In this colorful interpretation of two distant views, Monet creates a single, integrated vision.

■ Claude Monet, *Break-up of the Ice, Lavacourt*, 1879, Museo Gulbenkian, Lisbon.

■ Below: Claude Monet, *Camille on her Death Bed*, 1879, Musée d'Orsay, Paris.

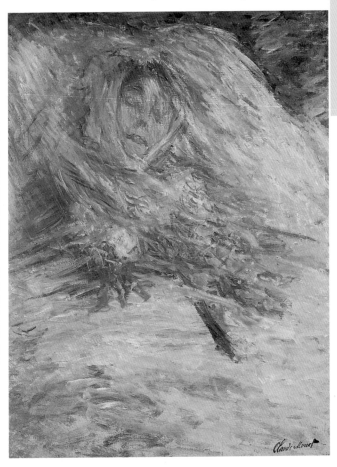

■ Above: Claude Monet, *Apples and Grapes*, 1880, The Metropolitan Museum of Art, New York. The charm and skill of Monet's still life work is encapsulated in this vibrant painting.

"La Vie Moderne"

The Impressionists' fourth and fifth exhibitions were held in 1879 and 1880. The fourth, called *Des Indépendants*, included a beautiful painting by Renoir, portraying the family of Georges Charpentier, who played an important role in Parisian art at this time in that he founded the periodical *La Vie Moderne* and opened a gallery in the same building, where the Impressionists held their one-man shows in turn. (In addition, Charpentier's wife held a salon, in which she brought together some of the city's major cultural figures.) Paul Gauguin was one of the exhibitors at the fifth exhibition and he became a regular participant from then on. These were also the years in which Durand-Ruel prepared to exhibit Monet's work abroad, although it would not be until 1905 that his work met with a rapturous response. In 1883, Renoir's *Luncheon of the Boating Party* was exhibited by Durand-Ruel in Boston.

■ Above: Alexander III Romanov is pictured with his family in a photograph taken in 1881.

■ Right: Actresses such as Sarah Bernhardt and Carolina were the superstars of the age.

■ Medardo Rosso, *The Concierge*, 1883, Museo Medardo Rosso, Barzio, Italy. This Italian sculptor was one of the most innovative artists of his age. Expelled by the Academy, he pursued his own individual style, which was greatly admired by the French sculptor Auguste Rodin.

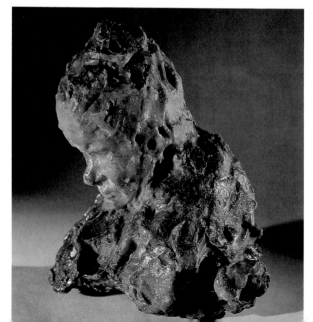

■ The American Thomas Alva Edison (1847–1931) was the most famous inventor of the modern age. He invented the first duplex telegraph system in 1864, the phonograph in 1877, and designed the world's first power station in New York in 1822. He also discovered what came to be known as the "Edison effect", the phenomenon of the flow of electric current from a filament to a plate of metal inside a lamp globe.

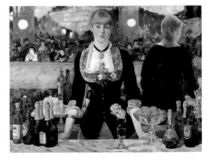

■ Edouard Manet, *A Bar at the Folies-Bergère*, 1882, Tate Gallery, London. This enigmatic portrait was Manet's final masterpiece. The barmaid, apparently lost in her own thoughts, has a powerful presence.

■ This 1887 satirical vignette from the Italian magazine *Il pappagallo* pictures the Italian minister Crispi, the German Bismarck, and the Austrian Kalnoky.

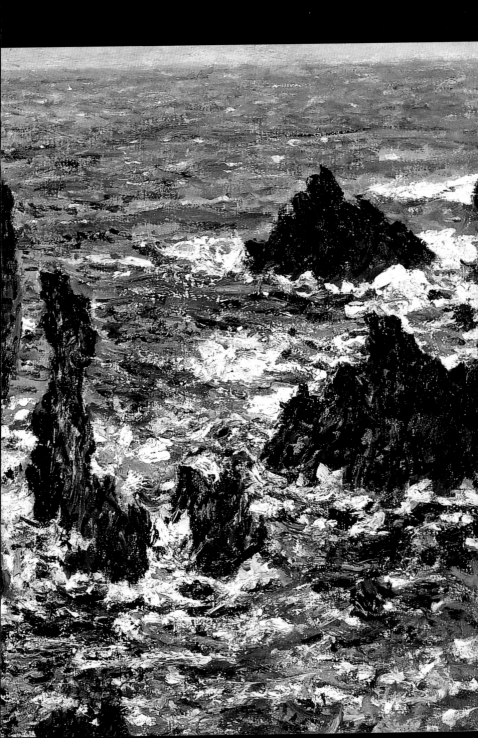

LIFE AND WORKS

New travels

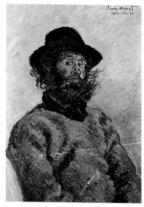

Monet wrote in 1883: "I am ecstatic, Giverny is a marvellous place for me...". However, he was away from his beloved home on painting campaigns for long spells. After visiting Cézanne, who was working in the gulf of Estaque, he spent a few months on the Italian Riviera, painting several series of works on the same subjects. In letters to Alice Hoschedé (with whom Monet was now in love), he told her that he thought only of her, and that he preferred the countryside to life in Paris. Keen to sell his work and to see himself fully established as an artist, he took part from 1885 in the international exhibition mounted by Georges Petit in his Paris gallery. One reason for this was that he did not want to depend on just one dealer, Durand-Ruel, who insisted on taking his paintings to the United States, against Monet's wishes. In 1885, Monet also enjoyed weekly dinners with Renoir and Pissarro at the Café Riche in Paris. Mirbeau wrote an enthusiastic article about Monet in *La France*; but, on a sour note, Monet entered into an argument with Émile Zola, who had described him as a failed artist in his novel *L'Oeuvre*.

■ The famous cliffs at Port-Coton, known as Les Pyramides, are pictured here in a postcard dating from 1900.

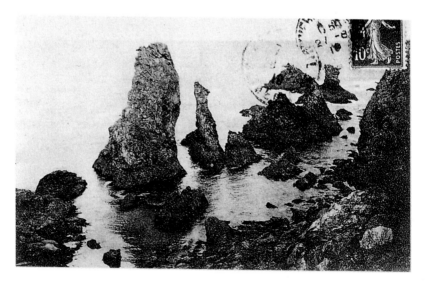

■ Claude Monet, *Bordighera*, 1884, Private Collection. Enchanted by the Riviera landscape, Monet radically changed his palette.

■ Right: Claude Monet, *Boats at Winter Quarters at Etretat*, 1885, The Art Institute of Chicago. This Normandy scene is alive with love for the sea.

■ Below: Claude Monet, *Bordighera*, 1884, The Art Institute of Chicago. Monet commented that he wasted a lot of paint because he found it "terribly difficult" to reproduce this landscape, which had "too many blues and pinks".

■ Claude Monet, *The Manneporte, Etretat*, 1883. These three paintings are from Monet's series of paintings of the great rock arch known as The Manneporte at Etretat (it derives its name from the Latin *magna porta*). The writer Guy de Maupassant, whom Monet met in this area, described the rocks at Etretat as "the leg of a colossus and the foot of a dwarf". Before him, Courbet, too, had visited Etretat, also drawn by the choppy sea and craggy rocks.

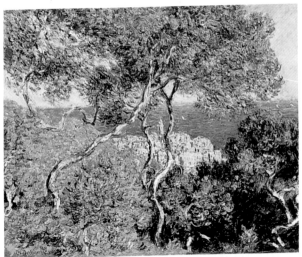

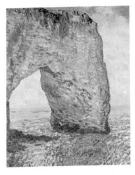

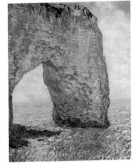

BACKGROUND

A progressive spirit

As the turn of the century approached, there was a feeling of increasing excitement. Major scientific discoveries were made at this time, including the discovery of micro-organisms by Louis Pasteur. In politics, events of great importance took place: more colonies were established in Africa and, in Britain, universal male suffrage was achieved. Art kept apace with the progressive spirit of the times: the Statue of Liberty was built in New York, and works of art by American artists were becoming as well regarded as those by European masters. Themes connected with work gained in importance; a handful of painters and sculptors had begun to introduce these from the mid-century. Running parallel with the Positivist and Symbolist aesthetic was divisionism, the painting technique based on scientific theory and practiced by the Pointillists. Unmixed color was applied in small dots, and when viewed from a distance, images would emerge rather like an optical illusion. This presented the public with a new challenge, for the color effects were achieved in the actual viewing of the work by the spectator.

■ Below: Auguste Rodin, *The Kiss*, 1886, Musée Rodin, Paris. Initially rejected by the traditionalists, the great Parisian sculptor came to be celebrated for the originality of his work. He preferred a naturalistic style to the idealization of conventional sculpture.

■ Louis Comfort Tiffany, *Autumn Landscape*, stained glass window, 1923, The Metropolitan Museum of Art, New York.

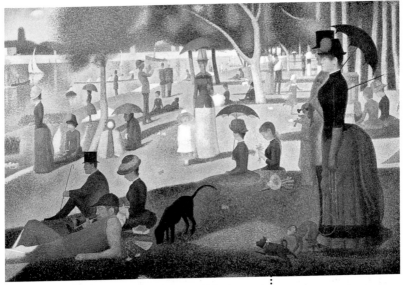

Seurat and optics

Above: Georges Seurat, *Sunday Afternoon on the Island of La Grande Jatte*, 1884–86, The Art Institute of Chicago. With his painstaking Pointillist method, Seurat took his art beyond the limits set out by the color theorist Eugène Chevreul, who had determined the existence of primary and secondary colors. His aim was to transcend the limitations of normal vision.

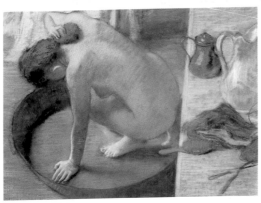

■ Edgar Degas, *The Tub*, 1886, Musée d'Orsay, Paris.

■ Here, Louis Pasteur watches over a colleague immunizing a patient against rabies. He had discovered the vaccine in 1885.

■ Edgar Degas, *Women Ironing*, 1884, Musée d'Orsay, Paris.

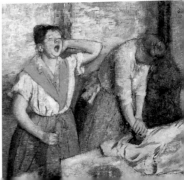

Three Fishing Boats

Painted in 1885 or 1886, this work is now in the Szépmüvészeti Museum, Budapest. It is one of the finest paintings of Etretat painted by Monet during the 1880s. Unremarkable in its subject matter, its painterly treatment is nevertheless impressive.

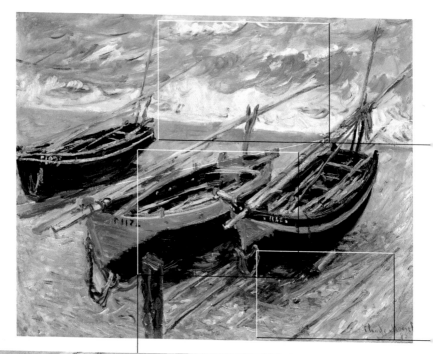

■ While painting in the picturesque fishing village of Etretat, Monet did not just restrict himself solely to grand landscape views, but also captured the human aspects of the area. In terms of technique, the use of black is interesting, applied over other colors for a striking effect. Yellow, green, and a touch of red are used for the painted edges of the boats.

■ Beyond the greyish blue line that traces the edge of the beach, there is a choppy, greenish sea. The white of the breakers is painted with a few touches of yellow, green, and blue. Green curling brushstrokes indicate where the wave swells, while the ripple of the water is suggested by a final touch of white. The sea fascinated Monet and he observed it in many different weather conditions and from a variety of angles. The detail above illustrates the extreme skill of his technique in conveying the essence of water.

■ The beach has been painted with care: as well as the combination of yellow and green, Monet uses red, blue, and black. The long timbers on which the boats rest blend with the complex texture of the wet sand. The gentle bobbing movement of the boats is suggested by the curved brushstrokes.

Beloved nature

In 1887, Monet's finances gradually began to improve: his customers included Theo van Gogh, brother of Vincent, who purchased one of the Belle-Île seascapes. The annual exhibition at Petit's gallery drew favorable comments from, among others, Joris-Karl Huysmans, author of *À Rebours* ("Against Nature"), the literary manifesto of Symbolist painting. John Singer Sargent, one of the most famous artists outside France, came to visit him. In January 1888, Monet set off for the Côte d'Azur, where a stay in Antibes produced some enchanting views. In 1889, he discovered the Creuse region, with, as he described it, "staggeringly beautiful" scenery that reminded him of the wild landscape of the North. He was afflicted with a serious rheumatic problem, the consequence of a minor accident, which forced him to wear a special glove to paint and affected his technique.

■ Below: Claude Monet, *Valley of the Creuse, the Petite Creuse,* 1889, The Art Institute of Chicago. In this painting, the first in a series, the bright sunlight dictates the colors of the whole scene.

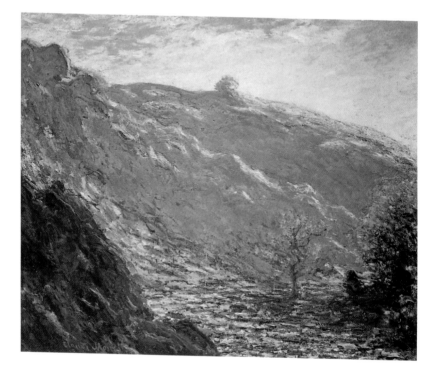

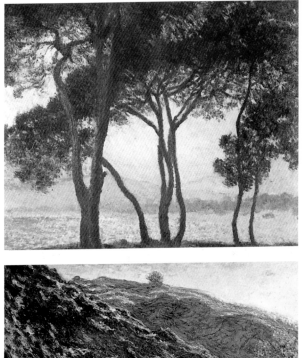

■ Above: Claude Monet, *Antibes Seen from La Salis*, 1888, Museo de Arte Contempòraneo, Toledo. Despite the many colors used – yellows pinks, greens, and blues – the painting, illuminated by bright sunlight, retains its coherence.

■ Above right: Claude Monet, *Juan-les-Pins*, 1888, Private Collection. One of a pair of paintings, this version is painted in warm colors whereas its partner is dominated by darker greens and blues.

■ Above: Claude Monet, *La Petite Creuse*, 1889, Private Collection. This painting depicts the same view as that shown opposite. The two works were possibly produced on the same day, in dramatically different light conditions.

■ Left: This postcard from about 1900 shows the confluence of the two arms of the River Creuse near Fresseline.

The end of the 1880s

■ This front page of *L'Aurore* shows Émile Zola's famous accusatory article, which claimed a judicial error and cover-up in the Dreyfus Affair.

The 1880s drew to a close with new, important milestones. Russia and Germany signed a treaty of understanding and mutual neutrality in the event of either waging war against another country. France and Great Britain pursued their expansion in the Far East and in Africa. In architecture, in 1889 the Eiffel Tower was built in Paris for the Exposition Universelle marking the triumph of the "New Architecture". On the cultural scene, these intense years saw the flourishing of the Symbolist movement. It was no longer enough, argued the Symbolist poets, writers, and painters, to satisfy a craving to portray reality: artists should set themselves new aims, elevating aesthetics to a higher sphere, striving to attain a more spiritual and less materialistic sensibility. This decade saw the beginnings of Post-Impressionism, which represented a progression from Impressionism in its pursuit of physical realism.

■ Shown here is one of the entrances to the Paris Métro stations, designed in the Art Nouveau style by Hector Guimard in 1889–1904.

■ Below: J.-F. Raffaelli, *Waiting for the Wedding*, 1898, location unknown.

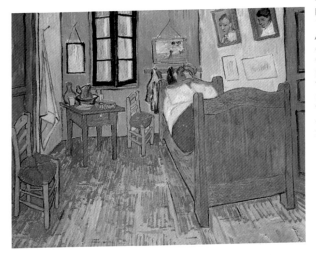

■ Vincent van Gogh, *The Artist's Room at Arles*, 1889, Musée d'Orsay, Paris. Van Gogh intended this painting of his bedroom to express a "feeling of perfect rest"; however the strange perspective and steep angles are somewhat disturbing. One of three virtually identical paintings, its colors are classic van Gogh – pure, thick, and vibrant.

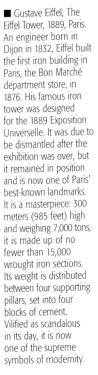

■ Gustave Eiffel, The Eiffel Tower, 1889, Paris. An engineer born in Dijon in 1832, Eiffel built the first iron building in Paris, the Bon Marché department store, in 1876. His famous iron tower was designed for the 1889 Exposition Universelle. It was due to be dismantled after the exhibition was over, but it remained in position and is now one of Paris' best-known landmarks. It is a masterpiece: 300 meters (985 feet) high and weighing 7,000 tons, it is made up of no fewer than 15,000 wrought iron sections. Its weight is distributed between four supporting pillars, set into four blocks of cement. Vilified as scandalous in its day, it is now one of the supreme symbols of modernity.

Painting at Antibes

Monet travelled to the Mediterranean at the beginning of 1888. The southern light astonished him, and he was obsessed with capturing its essence. He was often as frustrated as he was pleased with his results.

■ *The Beach at Juan les-Pins*, 1888, Acquavella Galleries, New York. Part of a series of seven paintings on the same theme, this was painted near the Château la Pinède, where Monet was lodging. The mass of green does not overpower the other colors; in fact, a harmony of color and light is achieved, with the soft distant shape of the mountain in the background.

■ *Antibes Seen from La Salis*, 1888, Private Collection. This painting is one of a series on the old town in Antibes. It was painted in the early morning, when the light on the water was very clear and the trees still in the shadows. The other paintings in the series show different times of day, including the afternoon, when everything takes on a red-mauve color, and the sea deepens to sapphire.

■ *The Old Fort at Antibes*, 1888, Museum of Fine Arts, Boston. During his long sojourn in the south of France in 1888, Monet produced a series of six paintings of the old fort. He uses a succession of minute brushstrokes, carefully balancing the pink, turquoise, emerald, and blue – not a single stroke of color is superfluous.

■ *Antibes Seen from the Cape, with the Mistral Blowing*, 1888, Private Collection. This painting demonstrates how Monet experimented with the interaction between foreground and background in his work. The mistral, which dominates the coast and areas inland, can be ferocious; it seems to purify the atmosphere and makes all colors appear sharper.

Poplars and haystacks

Although Monet was among the hundred or so artists whose work was showcased at the 1889 Exposition Universelle, it was a work by his late friend and fellow Impressionist Manet that stole the show: *Olympia*. When John Singer Sargent found out that Manet's widow was negotiating with an American buyer, Monet instigated a campaign to purchase the painting and present it to the state – this would be achieved the following February. In the same year, Monet successfully exhibited works alongside Rodin at Petit's gallery. His fame was increasing, and Mirbeau wrote of the paintings, "Air floods through every object, fills it with mystery, envelops it with every possible shade, now muted, now bright…." Thanks to a loan from Durand-Ruel, in November 1890, Monet was able to buy the house and estate at Giverny, which until then he had only rented. This was the beginning of a long phase of creativity, financial prosperity, and fame. He had long since ceased to be the pioneering young Impressionist he had once been and his style was increasingly governed by scientifically based notions. He was conscious of his status as head of a school of painting and history would bear out the importance of his role.

■ Claude Monet, *Poplars*, 1891, Museum of Art, Philadelphia. The artist loved these trees by the river and would gaze at them for hours. When they were due to be sold, he acquired them for a modest sum.

■ Claude Monet, *Poplars*, 1891, Metropolitan Museum of Art, New York. Monet worked on each painting in this series for about seven minutes, concentrating his powers of vision and execution to the maximum degree. The brushstrokes are strong, compact, and quickly applied as they follow the changing light.

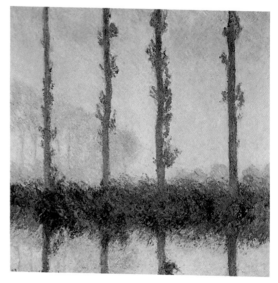

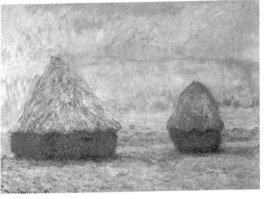

■ Claude Monet, *Haystacks, Morning Effect*, 1890, Private Collection. Monet made a major contribution to the concept of series painting. Between October 1890 and January 1891, he produced no fewer than 25 paintings of haystacks.

■ Claude Monet, *Haystacks (Sunset, Snow Effect)*, 1890–91, The Art Institute of Chicago.

■ Claude Monet, *Haystacks (End of Summer)*, 1890–91, The Art Institute of Chicago. Some of these works were exhibited in Moscow in 1895 and the Russian expressionist Kandinsky was among those who were influenced by them. He felt that the haystack seemed like something "other" than itself.

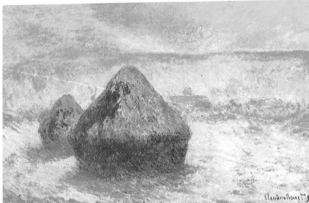

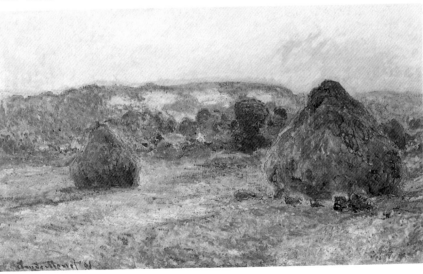

A new sensibility

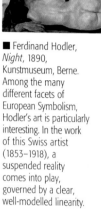

■ Ferdinand Hodler, *Night*, 1890, Kunstmuseum, Berne. Among the many different facets of European Symbolism, Hodler's art is particularly interesting. In the work of this Swiss artist (1853–1918), a suspended reality comes into play, governed by a clear, well-modelled linearity.

E urope in the 1890s was shaken by political and financial scandals and, in the world of culture, dramatic events marked the onslaught of a new set of sensibilities. In 1892 in Munich, there was the first artistic "Sezession" or "Secession", the first official instance of a group of Academy artists breaking away from the Establishment and staging a more avant-garde exhibition of its own. The second Secession was held in Vienna in 1897 and the third in Berlin in 1898. The aim of the Secessionists, as well as other artists who rejected traditional artistic tastes, was to go beyond realism – now regarded as an obstacle to be overcome and conquered – and strive for a new vision of the world. The Symbolist movement was born, flourishing in literature as well as the visual arts. It was associated with such artists as Odilon Redon, Gustave Moreau, and Ferdinand Hodler, as well as Gustav Klimt, the first President of the Vienna Secession. Meanwhile, the decorative style of Art Nouveau, in some respects an offshoot of Symbolism, formed a fundamental bridge between the artistic and architectural culture of the 19th and 20th centuries.

ENCICLICA
DEL SANTISSIMO SIGNOR PONTEFICE
LEONE
PER DIVINA PROVVIDENZA
PAPA XIII
AI VENERABILI FRATELLI PATRIARCHI PRIMATI
ARCIVESCOVI VESCOVI

DELLA QUESTIONE OPERAIA

■ Left: Pope Leo XIII's *Rerum Novarum* encyclical on the social question expressed hope that workers would share the economic fruits of their enterprise.

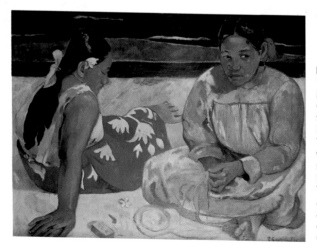

■ Paul Gauguin, *Two Tahitian Women*, 1891, Musée d'Orsay, Paris. Gauguin painted this famous picture during his second sojourn in Tahiti (1895–1901). It was exhibited at the major retrospective of his work held in 1906. The poses of the women are derived from the ancient Buddhist frieze of Borobudur, to which Gauguin often alludes.

■ German poster advertising the Second International exhibition, color lithograph, c.1890.

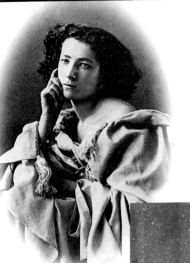

■ The French actress Sarah Bernhardt undertook a world tour in 1891, travelling to the United States, Australia, and Africa.

■ Gustav Klimt, *The Kiss*, 1905–09, Österreichisches Museum für Angewandte Kunst, Vienna.

LIFE AND WORKS

The northern light

W hen Ernest Hoschedé died in 1891, Monet was finally able to marry Alice and their wedding took place in July 1892. Although he was no longer young, this was the happiest time of his personal life and, professionally, the most fulfilling. From February 1892, he worked on the famous *Rouen Cathedral* series. While in Rouen, he thought constantly about his beautiful garden at home, and during those rare moments when he was not painting his favorite destination was the city's botanical gardens. Now confident in his painting and growing older in years, he felt that his style should undergo some modification, without sacrificing the principle he had always upheld – painting nature through whatever means in order to reproduce reality as best he could. In January 1895, he painted the Japanese bridge at Giverny, and dozens more versions would follow. In May, he exhibited more than fifty works at Durand-Ruel's gallery, including many of Rouen Cathedral. This represented a kind of apotheosis in his career, a state of affairs borne out by the prime minister's decision to buy the entire series for the nation.

■ Claude Monet, *Mount Kolsaas (Norway)*, 1895, Musée d'Orsay, Paris. During a journey to Norway, the artist painted many works of Mount Kolsaas. He devoted a stunning series of paintings to the subject, each based on the effect of the light on the snow. He had first been attracted to the beauty of this natural effect in his youth.

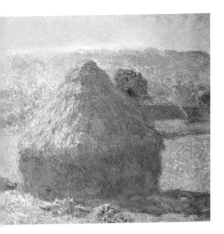

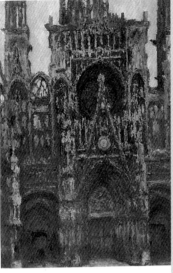

■ Claude Monet, *Haystacks (Late Summer, Morning Effect)*, 1890–91, Musée d'Orsay, Paris.

Here, tiny strokes of blue, green, yellow, and red produce a powerful visual effect.

■ Claude Monet, *Rouen Cathedral*, 1892–94, Musée d'Orsay, Paris. This painting shows the cathedral façade in predominantly dark tones; the subtitle is *Harmony in Brown.*

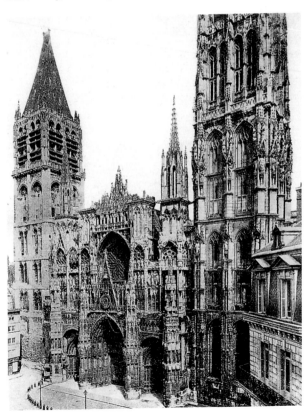

■ The historic town centre of Rouen boasts a number of Gothic buildings, of which the cathedral, built in 1202–1530, is the most imposing. Exuberantly Gothic in style, and enriched with many decorative elements and elaborate features (including the bell-tower, which dates from the late 14th century), its façade is a lacy network of stone carving that sheds a flickering pattern of light and shade onto the square. It was these very effects of light and color that fascinated Monet.

People and ideas of the 1890s

Not long after Monet began his *Rouen Cathedral* series, another great genius established himself: *Prélude à l'après-midi d'un faune,* one of the most beautiful pieces in modern music, was composed by Claude Debussy in 1894. Some musicologists see in Debussy the Impressionist technique translated into music, while other, more recent theorists group him with the Symbolists. His *Nocturnes, La Mer,* and *Preludes* were freely composed, each sound suggesting images, sensations, and colors, captured in a fleeting moment. Debussy was by no means the only composer working along these lines at this time, but he was unique in breaking away from the previous tradition and forming a bridge towards the music of the future. Meanwhile, in the art world, Cézanne held his first important one-man exhibition; it was staged in 1895, through Vollard, the gallery owner who favored the avant-garde.

■ Oscar Wilde's *The Importance of Being Earnest* was first performed in 1895.

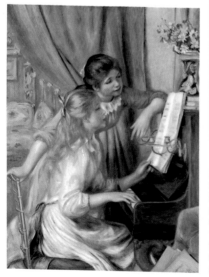

■ Pierre-Auguste Renoir, *Girls at the Piano,* 1892, Musée d'Orsay, Paris. After a period of artistic experimentation in the 1880s, Renoir returned to familiar, traditional themes, such as this domestic scene.

■ Henri de Toulouse-Lautrec, *The Singer Yvette Guilbert Singing "Linger, Longer, Loo",* 1894, Pushkin Museum, Moscow. The singer is shown in the long black gloves that were her trademark.

Horta and Art Nouveau

The Belgian architect and designer Victor Horta was one of the most important exponents of Art Nouveau in Europe. In the Hôtel Solvay in Brussels (1895–1900), all the features typical of the style were showcased. Horta was responsible for the entire building, including its contents, which were rich in fine fabrics and traditionally crafted materials (marble, glass, and wood). One distinctive Art Nouveau feature was the use of line as a purely decorative element, especially in wrought iron, where it appeared in a variety of distinctive and elaborately curved patterns.

■ On December 28, 1895, the brothers Lumière presented the first six short films in the history of the cinema in a Paris hall. Pictured here is *L'Arroseur arrosé.*

■ In this calendar from 1893, Germany, Austria, and France are pictured with their suitors Great Britain, Italy, and Russia.

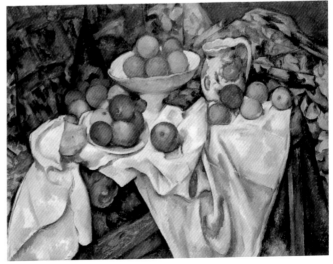

■ Paul Cézanne, *Still Life with Apples and Oranges*, 1895–1900, Musée d'Orsay, Paris. Although Cézanne took part in two of the Impressionists' exhibitions (1874 and 1877), he declared his absolute artistic independence from the group. Poorly reviewed by critics, he left Paris and returned to his native Provence. There, wracked by many doubts, he developed a style dominated by his structural exploration of natural objects, helping to pave the way for contemporary art.

Rouen Cathedral

Monet's great *Rouen Cathedral* series, made up of about 30 paintings, was executed between February and mid-April in 1892 and 1893. Such was his impulse to capture the uniqueness of momentary light effects that he painted no fewer than 14 pictures in a single day. This version is in the Pushkin Museum, Moscow.

■ This detail shows the central part of the cathedral's façade. Monet described his working methods in his many letters: "…each day I add and find something I had previously been unable to see…how difficult it is to paint this cathedral! …the more I go on, the more I struggle to reproduce what I feel…." In April 1893, he wrote to his artist friend Helleu that perhaps some of the paintings "would do". The problem, for Monet, was that "everything changes, even the stone", yet he stubbornly persisted in his determination to capture the most fleeting atmospheric effects.

■ *Rouen Cathedral, Façade and Tower (Morning Effect).* The painter Jacques-Émile Blanche said of Monet's struggle to capture Rouen on canvas: "he turned this architecture into an atmospheric drama". In contrast to the Pushkin Museum painting, this Musée d'Orsay version is dominated by a bold range of deep blues, pale blues, and yellows, which reflect the effects of early morning. The artist is viewing the cathedral against the light and the sun therefore shines down diagonally onto the cathedral, forcing Monet progressively to reduce the amount of yellow in order to introduce more blue. Concerned that he was not painting as well as he should, Monet completed the Rouen paintings in his studio at Giverny. This was a practice he would continue to follow in years to come.

■ In the version titled *Rouen Cathedral, Façade (Grey Day)* (Musée d'Orsay, Paris), Monet undertook dozens of sittings at every hour of the day and in almost all weathers. Here, his perception is radically different from the version opposite. The cold, clear northern light shines through in the muted clouds of an overcast day; the colors become dark and faded, but every detail still emerges with consummate clarity.

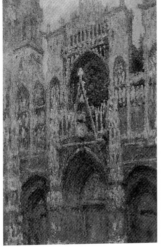

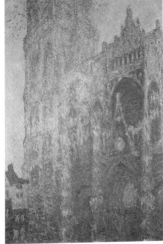

LIFE AND WORKS

A new obsession

Monet had come a long way from the humiliating rejections and misplaced prejudices of the Academy: he was truly established. On the occasion of the artist's exhibition of 1895, Monet's friend Clemenceau wrote that his work — and indeed Impressionism as a whole – was an entirely new expression of feeling. Monet worked and travelled unceasingly during this period, visiting, among others, Pourville, Dieppe, and Varengeville, and staging a one-man exhibition in Stockholm in February 1897. He invested a great deal of personal emotion in his garden at Giverny. Drawn, as ever, by the play of light on water, he began work on yet another series of paintings, dedicated to the garden's water lilies. In 1890, he confided to a friend: "Once again I have undertaken the impossible: water with reeds floating below the surface…beautiful to behold, but utter folly even to attempt it." In 1899, he began to paint the *Water Lilies* series.

■ Here, Monet stands by his beloved water lily pond and Japanese bridge at Giverny. It was only after something of a struggle that he obtained permission to dig the ground and create the pond.

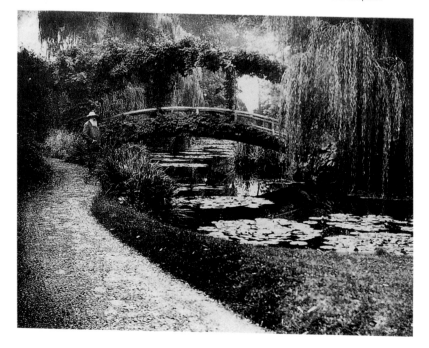

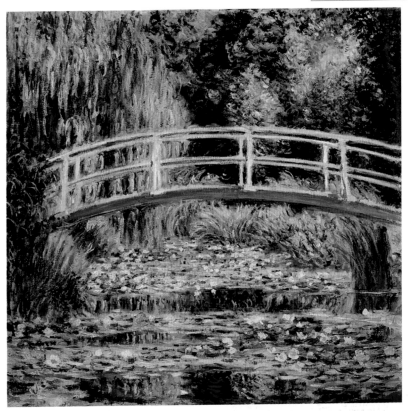

■ Claude Monet, *The White Water Lilies*, 1899, Pushkin Museum, Moscow. Obsessed by the idea of reproducing his flowers to perfection, Monet used every possible means to fix the beauty of nature on canvas. This series, dating from 1899, is made up of nine square canvases, the most suitable format for Monet to achieve a perfectly balanced composition.

■ Claude Monet, *Irises*, 1924–25, Musée Marmottan, Paris. In his quest for an absolute interaction with nature, Monet also painted the garden's weeping willows and irises – with stunningly beautiful results. Here, the color is applied almost in thick strands, and the faithful rendering of the flowers is superseded by the artist's inspired interpretation of them.

The century closes

The final years of the 19th century saw the death of some important cultural figures, including, in 1896, William Morris and the poet Paul Verlaine. Others enjoyed considerable professional acclaim during these years: the Norwegian painter Edvard Munch lived through his happiest period between 1892 and 1902, admired both in Paris and, more importantly, Berlin, where he influenced the artists who would later make up the Secession (1898). The Prix Goncourt was set up at this time and Puccini composed *La Bohème* in 1896. In 1895, the general confederation of work was instituted in France and, in 1897, the plan to create the Jewish independent state of Palestine was unveiled. Anarchic movements gained momentum in Europe at this time: in 1898, an uprising by a starving crowd in Milan demanding food was put down by military means in one of the cruellest acts of repression ever ordered by a European state in the modern age.

■ Emile Gallé, *the Roses of France*, 1900, Private Collection. This elegantly carved cut-glass goblet typifies Art Nouveau.

■ Camille Pissarro, *Rue Saint-Honoré – Rain Effect*, 1897, Thyssen-Bornemisza Collection, Madrid. As committed as Monet to the study of light, Pissarro painted a number of outdoor urban scenes during this period, and they are among his most interesting works. Like Seurat, he constantly experimented with style, and under the great pointillist's influence he developed his own Neo-Impressionist methods. Later, he returned to his looser earlier style. Like Monet, he suffered a deterioration in his vision in old age, and was to die blind.

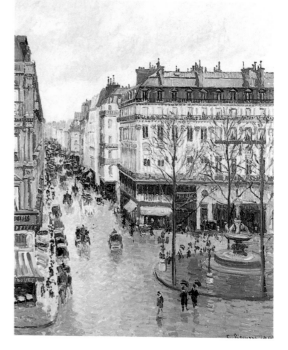

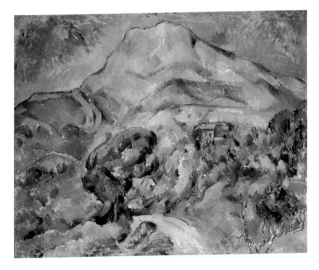

■ Paul Cézanne, *Mont Sainte-Victoire*, 1896–98, The State Hermitage Museum, St Petersburg. Cézanne, unlike the Impressionists, favored a limited range of subjects – this mountain in Provence among them – which he developed and reworked over the years. His treatment of the structures and volumes in natural forms paved the way for the "parallel reality" of the Cubists.

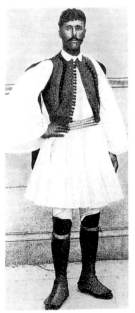

■ Paul Cézanne, *Bathers*, 1898–1905, Museum of Art, Philadelphia. Besides still lifes, bathers were Cézanne's favorite subject. Of his aims in painting, he said that he hoped to create from Impressionism "something solid and enduring". He analyzed and depicted the human body – and all aspects of nature – in geometric terms, identifying such structural elements as cones and spheres.

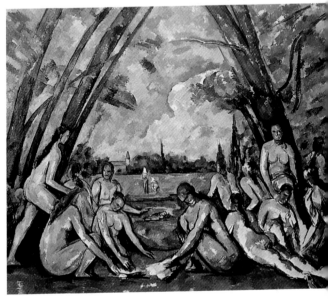

■ The marathon was introduced to the first modern Olympic Games, held in Athens in 1896 and promoted by the French Baron Pierre de Coubertin. Spyridon Luis, pictured here, was the winner.

1884–1899

Water Lily Pond, Harmony in Green

This beautiful painting of 1899, now in the Musée d'Orsay, Paris, is a companion piece to *Harmony in Pink* and part of an extensive series. The lines of the artist's much-loved Japanese bridge curve elegantly across the square canvas.

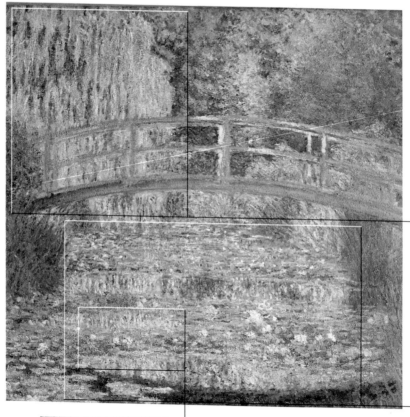

■ Monet adored his garden at Giverny with a passion that bordered on obsession.

■ This detail shows two features that recur frequently in Monet's masterpieces of the 1890s: the weeping willows and the Japanese bridge. The bridge, modelled on those in traditional Japanese gardens, was built after July 24, 1895, when the artist was granted permission to divert the flow of the nearby Ru stream so the water could pass through his estate. He then enlarged the natural pond, devoting considerable attention, time, and money to the project.

■ Positioning himself opposite the bridge (which was situated on the western side of the pond), the artist was able to watch the changing light conditions and the various light effects on the surface of the water, with its water lilies. By cross-fertilizing different species, Monet produced beautiful hybrids, which he tended with the help of a servant hired exclusively for this purpose. Here, the scene does not resemble Normandy at all, but is more reminiscent of an Oriental garden.

Claude Monet, *Vétheuil*, 1901, Pushkin

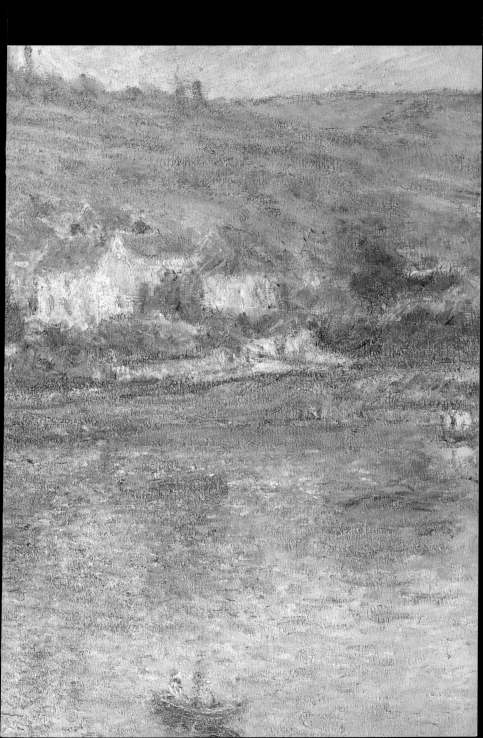

The magic of Giverny

Monet's reputation continued to grow and numerous exhibitions of his work were held during these years. In 1900, he returned to London, where between February and March he painted 65 versions of the River Thames and the buildings he saw from his room in the Savoy Hotel. In April, Durand-Ruel exhibited 26 of his paintings in New York, and, a month later, Monet was the most represented artist at the Exposition Universelle, held at the site of the Eiffel Tower. An entire room was devoted

to the Impressionists, with no fewer than 14 works by Monet. In January 1901, he was once again in London, putting the finishing touches to the paintings he had worked on the previous year. Then, in July, he rented a house at Lavacourt in order to paint the Seine. At home in Giverny, in August he was given permission to divert the Ru stream towards his estate, enabling extension work to be carried out in February 1902. In 1903, he took part in the 14th exhibition of the Viennese Secession.

■ Left: Monet is pictured in his studio with an enthralled Duc de Trévise. The two stand in front of the *Water Lilies* and paintings of other parts of the artist's garden, as well as the largest fragment of *Le Déjeuner sur l'Herbe*.

■ This photograph, taken in the 1920s, shows a path through the garden at Giverny, with its abundance of flowers and plants. The door to the house is framed by roses.

■ The artist, filled with yearning for the places he had once lived, revisited them in his work. Beautiful paintings of the riverside village of Vétheuil date from 1900–01.

■ Claude Monet, detail of *The Garden at Giverny*. Here, color is applied with thick touches and the foliage is vividly animated by the light.

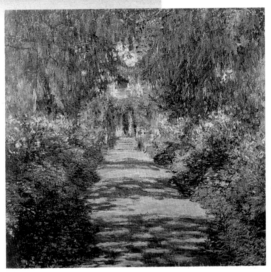

■ Claude Monet, detail of *The Garden at Giverny*, 1902, Österreichische Galerie, Belvedere, Vienna.

Depicted here in a riot of light and colour is the same path as that shown in the photograph opposite.

■ Claude Monet, *Waterloo Bridge (Sun in the Fog)*, 1902–04, National Gallery of Canada, Ottawa. Monet's paintings of London were produced over a number of years. Begun in 1899, they were completed in the studio by 1904. Painted from Monet's room at the Savoy, the green, pale blue, yellow, and red of this delicate view of the bridge reflect the artist's admiration for Turner.

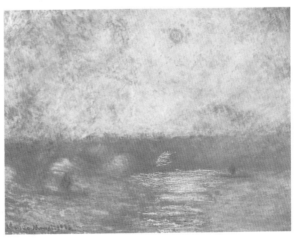

The turn of the century

■ Gold brooch, 1905.

As one century drew to a close, a new one was about to begin – with momentous events. In South Africa, British occupation of the Orange Free State and the Transvaal led to the Boer War, fought between 1899 and 1902, while in China, in 1900, the unsuccessful Boxer Rebellion was suppressed. Queen Victoria died in 1901, bringing the glorious Victorian age to a close. It was a time of political turmoil throughout the world, and Europe in particular experienced a great deal of suffering. In the art world, a number of key figures died, including Toulouse-Lautrec and Gauguin, but new groups came to the fore, such as the German Expressionist movement known as Die Brücke (the bridge), formed in 1905 in Dresden. Members of the group referred to van Gogh and Gauguin in their work, and are widely viewed as the first exponents of the avant-garde. In France, the so-called Fauves (wild beasts) represented the French Expressionist avant-garde, their works characterized by distorted lines and bold colors.

■ The zeppelin made its maiden flight on July 2, 1900. The rigid cylindrical airship was filled with hydrogen.

■ The Eiffel Tower rises proudly over the site of the Exposition Universelle of 1900.

■ The famous dancer and singer Jeanne Avril, the queen of the Paris cabaret at the turn of the century, was famously immortalized by Toulouse-Lautrec and worshipped by men of all ages. Parisians enjoyed a lively social life at this time, and the many bars opened after 1880 – from the Moulin de la Galette to the Moulin Rouge – enjoyed lucrative business.

■ Shown here is one of the galleries at the Salon d'Automne, which opened in 1903 and exhibited some of the most up-to-date trends in art. Manet was celebrated with a major retrospective here in 1905.

■ "Peacock" pendant in gold, opals, diamonds, emeralds, and enamel, 1900. Like the brooch (above left), this delicate pendant is housed in the Schmuckmuseum, Pforzheim, Germany.

■ This Majourelle-Prouvé piano, dating from 1903, is now in the Musée des Arts Décoratifs, Paris.

■ The machinery display at the 1900 Exposition Universelle offered visitors the chance to compare the technological advances of different countries.

■ In this panoramic view of Paris, looking south from the Opéra, the *ville lumière* sprawls out into the distance.

Vétheuil

Painted in 1901 and now housed in the Pushkin Museum, Moscow, this work is part of a series devoted to Vétheuil, the picturesque and unspoilt village on the Seine. As with some of the *Water Lilies*, Monet's chosen format is a square.

■ It is interesting to note how Monet captures the various elements of the view (buildings, rooftops, bushes, and the cathedral) in a riot of reds, oranges, whites, greens, and blues, all applied with short, fast brushstrokes. These combine to produce the perfect evocation of Vétheuil.

■ The treatment of the boat and the two people on board differs enormously from that of the fishing boats leaving the harbor at Le Havre in *Impression, Sunrise*. Here, the color is built up by means of tiny brushstrokes and is almost powdery in texture and effect.

■ As the Impressionists' painting developed, it became clear that the label of "landscape artists" was increasingly inaccurate. The depiction of landscape as the ultimate product of a composition was the least concern in the artists' minds. Architectural features or the texture of the soil are rendered through different shades of green, blue, and red, harmoniously blended with the aim of showing the viewer the myriad color impressions gleaming under the light.

■ Monet lived in Vétheuil from 1878, before settling at his beloved Giverny in 1883. For him, the river was a vital element in his surroundings. Here, he uses the landscape as a pretext for exploring the rippling, ever-changing surface of the water. This approach would culminate in the masterpieces devoted to his garden at Giverny. As the green shades of the river bank recede, the color becomes a soft, shimmering blend of pinks and reds.

1900-1912
Paintings of Venice

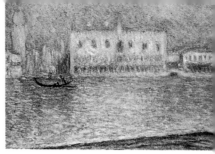

Camille Pissarro died on November 15, 1903, and was universally mourned. To celebrate his life, Durand-Ruel mounted an exhibition in April, which reviewed the great artist's entire output. In May, he organized a highly successful exhibition of Monet's Thames paintings, with a catalogue introduction by the critic Octave Mirbeau. Monet continued to work unstintingly and obsessively on his *Water Lilies*, but delayed exhibiting them in public. In 1905, Durand-Ruel mounted a further exhibition devoted to Impressionism, this time at the Grafton Galleries in London. This, too, was enormously successful for all the artists taking part. More exhibitions followed in Toledo (Ohio), Bremen, Boston, and New York, and sales of Monet's paintings to established European and American museums were secured. The artist, who had already had problems with his sight (he had nearly lost an eye in July 1900 in an accident that occurred while he was playing with his children), now complained of serious visual impairment, including blurred vision, a classic symptom of cataracts, and dizziness. In 1908, he went to Venice for the first time and spent many hours walking through its streets; among the many inspiring views that he captured on canvas was that of the Palazzo Ducale.

■ Claude Monet, *The Palazzo Ducale*, 1908, Private Collection. "The artist who conceived of this palace was the first Impressionist," said Monet in an interview. "He allowed it…to rise up from the water and shine in the light…just as the Impressionist painter allows his brushstrokes to shine on the canvas." In painting this great Venetian palace, Monet was following in the footsteps of Renoir (below).

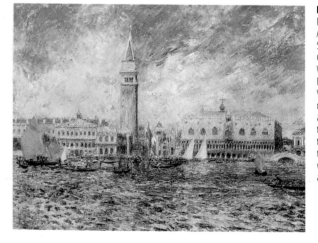

■ Pierre-Auguste Renoir, *Venice, the Palazzo Ducale*, 1881, Sterling and Francine Clark Art Institute, Williamstown (Mass.). Renoir's views of Venice were very well received. The artist felt a particular affinity with the city and exhibited these paintings in Paris to great acclaim. Monet was among those to admire them.

■ Claude Monet, *London, Parliament (Patch of Sun in the Fog)*, 1904, Musée d'Orsay, Paris. In this and other paintings of the Thames, Monet chose to focus on the relationship between the Houses of Parliament and the fog that surrounded the building, making it almost completely disappear in some paintings. The artist would interrupt and resume his work depending on the weather conditions.

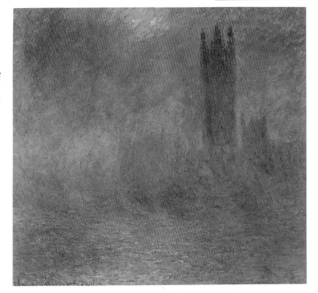

■ Claude Monet, *Water Lilies*, 1907, Private Collection. Monet's water lilies were a source of immense joy and artistic preoccupation.

His perfectionism led him to postpone by two years an exhibition of the final works, scheduled by Durand-Ruel to be held in 1907.

■ Claude Monet, *Water Lilies*, 1907, Private Collection. The journalist Lucien Descaves wrote of the exhibition: "I have seen living water in painting. It moves like the face of a happy young woman, whose mysteries have been unveiled before me, water clothed in shadow and unclothed by sunlight…."

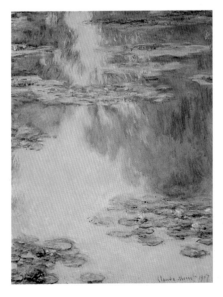

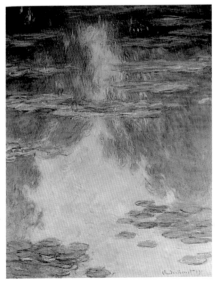

The avant-garde beckons

■ Right: Gustav Klimt, *The Embrace*, 1905-09, Österreichisches Museum für angewandte Kunst, Vienna. A key figure in the Austrian Secession, Klimt was originally a goldsmith. His art is a balance between Symbolism and material preciosity.

Echoing the success of the Salon des Indépendants in Paris in 1884, the annual Salon d'Automne was first held in 1903, and was to introduce many great artists of the future. A number of major retrospectives were also staged, including one devoted to Cézanne in 1906. If art was the herald of innovation at this time, science was no less so. During the early years of the 20th century, Sigmund Freud's writings on the interpretation of dreams and on sexuality were published, as were those by the revolutionary philosopher Henri Bergson on duration and movement. In 1903, Marie Curie and her husband were awarded the Nobel Prize for physics and great strides were made in the fields of astronomy and chemistry. In 1906, the Simplon railway tunnel connecting Switzerland and Italy was opened – one of the most important engineering feats of all time.

■ Wassily Kandinsky, *Improvisation XIV*, 1910, Centre Pompidou, Paris. The artist's work expresses his theories on the dissolution of natural form.

Picasso and the birth of Cubism

Pablo Picasso, *Les Demoiselles d'Avignon*, 1907, Museum of Modern Art, New York. This is one of the most important paintings of the 20th century and is widely considered to be the manifesto of Cubism. Attracted to African art, Picasso was moving away from the realist style, which he had explored during his formative years, and towards the distortion of form. The two women on the right are portrayed with the rigid features typical of early Cubism.

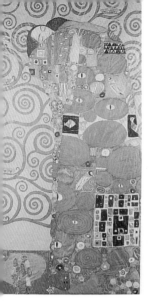

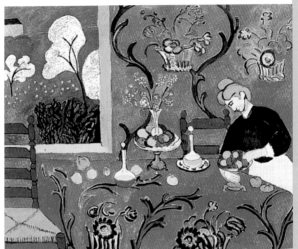

■ Henri Matisse, *The Red Room*, 1908–09, The State Hermitage Museum, St Petersburg. Matisse was one of the key Fauve artists; like Picasso, he was inspired by African sculpture.

■ Below centre: This poster was designed by Leopoldo Metlicovitz for the International Exhibition held at the site of the Sforza castle in Milan in 1906. Like many other European cities at this time, Milan, too, was enjoying a lively period of change, expansion, and artistic renewal.

■ André Derain, *Waterloo Bridge*, 1906, Thyssen Bornemisza Collection, Madrid. The Fauvist painter Derain was an early exponent of Cubism.

■ The apartment of the author Colette, Palais-Royal, Paris, c.1981.

■ Pablo Picasso, *Woman with a Fan*, 1909, Pushkin Museum, Moscow. The tone of this image is dominated by the monochromatic palette.

MASTERPIECES

The Water Lily Pond

Dating from 1904, this painting is now in the Musée d'Orsay, Paris. It is one of the most beautiful of Monet's early water lily paintings; the thickly applied color remains soft and delicate and light and shade have been carefully balanced.

■ The leaves hold the flowers like an open hand. Intensely white, the water lilies gleam in the green darkness. They attract the scant light around them and contrast with the reflection on the water, which creates a wide, light area and hints at the depth of the pond.

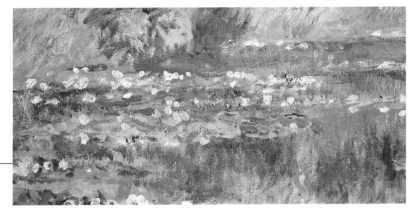

■ The obsession Monet had nurtured from as early as 1890 drove him into a kind of productive frenzy; in 1902, he had painted no fewer than 48 *Water Landscapes*, of which his friend Gustave Geffroy wrote: "…and in the water, among the flowers, one can see the sky filtering sunlight all around, the breeze through the trees, the nuances that mark each different time of day, a delicate, complete picture of nature". In 1907–08, Monet also used the circular format because, like the square, this enabled viewers to concentrate on the centre of the composition and lose themselves in its colors.

■ As would be his practice in years to come, Monet here focuses on the relationship between the pond's surface and its depths, between what is visible and what is unseen. He wrote: "The basic element of the motif is the mirror of water, which changes its appearance every moment." Here, the dark green mass of the tree covers the right-hand side of the pond, darkening it and making that part of it seem deeper. Greens and blacks interact in order to build up a coherent picture when viewed from a distance.

LIFE AND WORKS

Success and disappointment

■ This photograph shows Paul Durand-Ruel's studio in his New York home. The dealer, who had gone into business in 1865, opened a gallery in London in 1870. In order to broaden the market for Impressionist works,

The two journeys he made to Venice were to be the last times Monet would venture out of Giverny. His eyesight was failing fast. In Venice, however, he was still able to feel an inner strength. He was very excited by the city, and openly declared his enthusiasm for it. He said of the Palazzo Ducale: "When I painted this painting, it was the very atmosphere of Venice I was trying to paint. The palazzo which features in the painting was a mere pretext to enable me to convey the atmosphere." He returned to Venice a second time, in 1909, and worked on paintings of the city until 1912, the year in which 29 were exhibited at Bernheim-Jeune's gallery. But these were far from carefree years for the master: Alice, who had brought him so much happiness, died in 1911, and Jean, his eldest son by Camille, died in 1914. To help him cope with his grief, Clemenceau wrote to him with the advice that he should try to think of Rembrandt – an artist Monet admired – and how he had been able to find the strength to endure many adversities. Monet's health was also poor. In June 1910, he complained of recurring headaches and sought medical help. Friends lavished love and respect on him and were frequent visitors to Giverny, and he was sought after by museums and collectors. His painting was still an anchor to which he could cling.

he also staged many exhibitions in New York. There, the group's style was successfully introduced, thanks partly to the contribution of Whistler and Sargent, who had close links with the group.

■ Claude Monet, *Water Lilies, the Irises*, c.1910–15, Kunsthaus, Zurich. It would be misleading to categorize Monet's last *Water Lilies* as entirely nonrepresentational or conceptual. However, such works might be viewed as precursors of Abstract Expressionism.

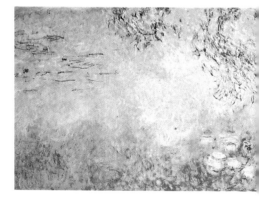

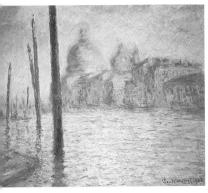

■ Claude Monet, *The Grand Canal*, 1908, Private Collection. In this delicately coloured painting of the Grand Canal, Venice, Monet sacrifices the study of the architecture in favor of the light that surrounds it.

■ Claude Monet, *The Grand Canal and the Salute Church*, 1908, Museum of Fine Arts, Boston. Octave Mirbeau was among the many admirers of Monet's Venice paintings. He wrote: "The reflections pile up...[the sun] is mixed with the color as though it had passed through the rose of a stained-glass window."

■ Below: the master is pictured in his studio at Giverny in the late 1910s. Stubborn and meticulous, Monet turned his studios into highly organized work spaces, where he would only receive guests at times that were convenient to him.

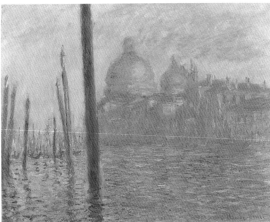

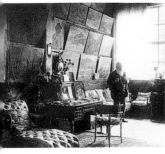

■ This photograph of Monet, cigarette in hand, shows him as a distinguished and elderly gentleman acclaimed by all.

113

A frenzied new century

While Monet was living through a period of great professional success and private turmoil, world events gathered momentum. There was an assassination attempt on the King of Portugal; an anti-Greek insurrection occurred on Crete; Bulgaria achieved independence; Macedonia was granted its own constitution; the Union of South Africa was born; and Mongolia and Tibet broke away from China. These were only a few of the major events that took place during the intense early years of the new century. Elsewhere, in New York on March 8, 1908, 129 female workers employed by the Cotton textile factory died when the building burned down in one of the worst tragedies ever to occur in the workplace. It was during this period that Arnold Schoenberg wrote his *Treatise on Harmony*, in which he expounded the concept of what would come to be known as "atonal" music, influencing many contemporary musical trends, and Rudolf Steiner's Anthroposophical Society was created. Other events included a successful expedition to the South Pole, the founding of the newspaper *Pravda* in Russia and Paris in 1912, and a spectacularly daring theft from the Louvre of the *Mona Lisa*. The painting was safely returned on 21 December.

■ Enrico Caruso (1873–1921) was the outstanding tenor of the age.

■ Emperor William II, centre, between generals Ludendorff and Hindenburg.

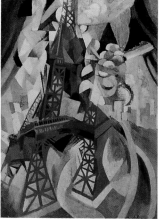

■ Marc Chagall, *Dedicated to my Wife*, 1911, Kunstmuseum, Berne. This totally original, independent Russian artist was one of the key foreign figures in Paris during these years.

■ Robert Delaunay, *The Red Tower*, 1911, The Solomon Guggenheim Collection, New York. Influenced by Cézanne, Delaunay was one of the founders of Orphic Cubism, an abstract style of art with Cubist affinities.

■ The enormous cruise liner *Titanic* sank on its maiden voyage on April 14, 1912, a terrible human tragedy and blow to progress.

■ Pendant in gold, agate, ruby, and paste, 1902, Schmuckmuseum, Pforzheim, Germany.

The Italian Futurist movement

In 1909, the poet Marinetti published an article inviting bold young Italian artists to join him in his fight against the Academy. Five responded to the challenge and, the following year, Futurism was created – Italy's first avant-garde movement. Umberto Boccioni, the most gifted member of the group, was also the one most open to new ideas, and with the keenest instinct for change. His work, *The City Rises* (1910–11, Museum of Modern Art, New York) is the manifesto of the Futurist style, depicting the group's favorite themes: a city under construction, with factories and smoking chimneys, and the eternal clash between man and nature, represented by the horse. The use of pure color applied in parallel strokes emphasizes a sense of movement and dynamism.

■ Antoni Gaudí's La Sagrada Familia was the masterpiece of one of the most gifted architects of the modern age. The leader of Catalan Modernism, he was inspired by the fantastical and daring achievements of Gothic art.

Claudio Monet 191

A boundless energy

Monet's style continued to meet with an excellent critical reception. He was particularly popular in the US, so much so that his presence at the Armory Show, the controversial international exhibition of modern art, ensured that five of his paintings went on to be shown in exhibitions in Chicago and Boston. In 1914, work began on the studio – his third – where he would work on the famous oval canvases, which would then be transferred to the Orangerie. The new studio was a huge space, 25 x 12 metres (82 x 39 feet) and 15 metres (49 feet) at its highest point. Having already endured the death of his firstborn son, Jean, Monet was now parted from his other son, Michel, a volunteer in an infantry regiment. (To support the soldiers who were prisoners of war, the artist frequently made donations to charity organizations.) He was left alone with Blanche Hoschedé, who was a devoted companion to him during his last, painful years. In November 1916, he invited the artist Pierre Bonnard, the esteemed member of what had once been the Nabis group, to inspect progress on the *Water Lilies*.

■ This photograph shows Monet's large water lily pond, the corner of paradise that he created out of nothing. Unfounded fears were provoked among the neighbors that the presence of the water lilies might pollute the water.

■ Claude Monet photographed in his beloved garden in about 1917.

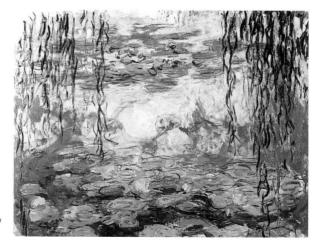

■ Claude Monet, *Water Lilies*, 1916–19, Musée Marmottan, Paris. In this painting, thick, dense brushstrokes and horizontal and circular streaks powerfully convey the shape of the flowers.

■ This postcard from the 1920s shows the now famous water lily pond. The reflection of the light on the water, which Monet strove obsessively to capture, can be clearly seen.

■ Claude Monet, *Water Lilies*, 1916–19, Musée Marmottan, Paris. Although the public had already seen Monet's treatment of the water lily theme at Durand-Ruel's exhibitions of 1900 and 1909, the artist continued to cling stubbornly to the subject. He worked in his new studio only in the winter months, preferring to paint out-of-doors whenever possible.

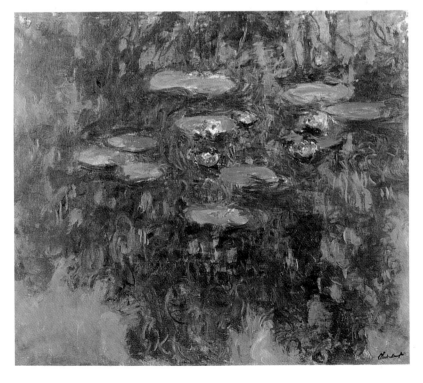

War and change

■ Giorgio de Chirico, *The Disquieting Muses*, 1916, Private Collection, Milan. De Chirico was one of the chief exponents of the avant-garde painting style Pittura Metafisica. After the burst of energy that characterized Futurist art, artists such as de Chirico and Carlo Carrà closed in on themselves and returned to classical models.

In 1914, Europe was divided into two large blocks, the Central Powers of Germany and Austria-Hungary (with their allies, Bulgaria, Turkey, and Italy) on the one hand and, on the other, the Allies – France, Great Britain, and Russia – among whom there was still a great deal of friction arising from unresolved disagreements over conflicts that had taken place during the previous century. Austria's annexation of Bosnia-Herzegovina in 1908 was a cruel blow to the anti-Austrian nationalistic factions. On June 18, 1914, a nationalist student killed Archduke Franz Ferdinand, heir to the Austro-Hungarian throne. Vienna put the blame for the assassination on the Serbian government and declared war. The other states followed suit. This devastating war, which saw the collapse and break-up of the Central Powers, did not end until 1918, and in January 1919, the various agreements accepting the new status quo were signed. In April, the League of Nations was set up, with the aim of resolving any future political or diplomatic conflicts. Against this eventful and volatile background, the arts in Europe were were on the threshold of a period of lively innovation.

■ The scientist Albert Einstein, born in Ulm, Germany, in 1979, published his *Theory of Relativity* in 1916. This was followed in 1929 by his *Unified Field Theories*.

■ Giacomo Puccini composed *Il Trittico* in 1918.

■ Marcel Duchamp, *Fountain*, 1917 (replica of the lost original), Studio Schwartz, Milan. Duchamp was the supreme example of the irreverent, maverick artist. Influenced by the Impressionists, Fauves, and Cubists, he invented a new kind of art, in which industrially produced objects (such as this urinal) are elevated in status to works of art. *Fountain*, exhibited in New York in 1913, caused a scandal.

■ Amedeo Modigliani, *Nude Reclining with Open Arms*, 1917, Mattioli Collection, Milan. Modigliani left his native Italy and settled in Paris in an effort to gain recognition for his elegant art, which was steeped in a medieval purity of line. He died in 1920, aged just 36.

■ Amedeo Modigliani, *Caryatid*, 1913–14, Museum of Modern Art, New York. Modigliani, a sculptor as well as a painter, was inspired by African art and its paring down of the subject to the essentials.

■ Marcel Duchamp, *Bottle Rack*, 1914 (replica of the lost original). Duchamp made use of the most banal ready-made industrial product, without the intervention of any standard artistic addition.

A stubborn old man

Asked if the *Water Lilies* he was working on could be photographed, Monet curtly replied that it was precisely because they were still being worked on that they were in no state to be photographed. His perfectionism had not dulled. On February 16, 1917, he suffered a further bereavement with the death of his journalist friend Octave Mirbeau, who had remained a constant ally through many difficult years. Monet now felt he was all alone; his eyesight began to deteriorate and he had to rely on color labels to avoid making mistakes. However, he had certainly not been abandoned by the great art institutions, which had excluded him from the market for years when he was young. In April, the minister for culture, commerce, and industry, Étienne Clémentel, discussed with him the possibility of creating a tapestry for Rheims Cathedral. The project never materialized. In November of that year, Monet's great friend Georges Clemenceau became prime minister and, the day after the Armistice was declared, Monet suggested to him that he might present the nation with two paintings in celebration of the victory. This was to lead to a far more ambitious project – the canvases created for the two oval rooms in the Orangerie. However, the political situation in France was extremely tense and Clemenceau was defeated in the 1920 elections.

■ Claude Monet, *Self-Portrait*, 1917, Musée d'Orsay, Paris. The artist spent the summer of 1917 working almost entirely in the open air. His mood was frequently melancholic.

■ Below left: Claude Monet, *View from the Rose Garden*, 1922–24, Musée Marmottan, Paris.

■ Below: Claude Monet, *The Water Lily Pond*, 1917–19, Musée Marmottan, Paris.

■ Claude Monet, *The Japanese Bridge at Giverny*, 1922–24, Musée Marmottan, Paris. This is one of the outstanding series of works devoted to the bridge that preoccupied Monet during his final years. These works are characterized by a style that draws on bold colors and fluid, almost agitated, brushstrokes that hint at a deep inner disquiet.

■ Claude Monet, *The Japanese Bridge at Giverny*, 1924, Musée Marmottan, Paris.

■ This photograph from about 1926 shows the bridge from the west. This little bridge, evidence of Monet's interest in Oriental culture, was another favorite subject during his long, creatively rich time at Giverny. Covered in climbing plants and shaded by a cascade of wisteria, it provided Monet with a constant source of artistic experimentation.

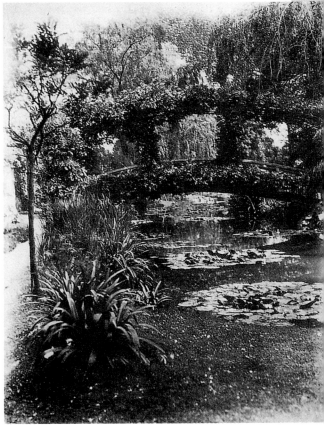

Bauhaus and Art Deco

Afer World War I, the map of Europe was completely redrawn, with new borders, new key figures, and a new sense of balance. The tranquillity this brought was illusory: major, tragic insurgences were silenced and Fascist and National Socialist political ideologies took on a strongly dictatorial stance during the 1920s and '30s. As the lights went out on an age of splendor and elegance (fostered by the aesthetic principles of Art Nouveau), industry became a dominant giant, imposing sweeping new rules. An anti-decorative ideal was now adopted, based on pure geometry and the elimination of all that was superfluous. The Bauhaus school of art and design was established in Weimar in 1919 and its designers were to make a key contribution to defining the new relationship between art and indudtry. Also significant was Art Deco: despite being initially associated with luxurious materials, this was essentially a style of simple, streamlined forms. Meanwhile, in literature, Franz Kafka painted a picture of modern life in which characters are often in the grip of a surreal nightmare, while, in philosophy, Bertrand Russell was among those who made important contributions.

■ Rosa Luxemburg, the German socialist agitator, was killed in Berlin in 1919.

■ This coffee-pot was made in the Bauhaus pottery workshop in 1923 (Kunstsammlungen, Weimar).

■ In keeping with a new aesthetic based on health and beauty, a smiling American pin-up girl strenghens her abdominal muscles.

■ *Harlequin*, c.1924, enamelled porcelain painted in cobalt blue, Museum of Decorative Arts, Prague.

A new way of teaching

The founder of the Bauhaus school, German-born architect Walter Gropius, surrounded himself with famous artists and designers, including Kandinsky and Klee. Students learned both the theory and practice of various crafts (the school syllabus is shown here) and lived harmoniously alongside their teachers. The Bauhaus was closed down by the Nazis in 1933.

■ The façade of Sommerfeldhaus was designed by Walter Gropius and Hannes Meyer in Berlin in 1921. Swiss architect Meyer was the head of architectural design at the Bauhaus; he developed totally original ideas in both his teaching and his own work.

■ This photograph shows the exhibition mounted by Durand-Ruel in London in 1905; it included many works by Monet and Renoir.

■ Kurt Schwitters (1887-1948), *Merzbild Rossfett*, 1918-19, Musée d'Art et d'Histoire, Geneva. Schiwitters was the most representative Dada artist in Hanover. Typical among his works are *assemblages* made up of different industrially related materials.

125

1913–1926

The last works

I n 1923, Monet underwent further surgery on his eyes, after which he was obliged to wear glasses that turned everything he saw a yellowish color. He added other spectacles, with tinted lenses, to correct the color distortion. This was so successful that he was able to resume his painting with renewed vigor. In the spring, he completed the final *Water Lilies*, but was so self-critical that he asked Blanche Hoschedé to burn several canvases in front of him, so he could be absolutely sure they had been destroyed. At the end of August, an incurable tumor on his left eye was diagnosed and the artist, now bedridden, became weaker and weaker. Clemenceau was at his side when he died on December 5, 1926. His funeral, which he had wanted to be a quiet, private affair, was attended by a crowd of mourners, led by Clemenceau. The artist had outlived most of his friends and family.

■ Below: the artist is pictured in his studio in the early 1920s.

■ Bottom: the beloved *Water Lilies*, completed in 1926, are seen on display in the oval gallery of the Musée de l'Orangerie in Paris.

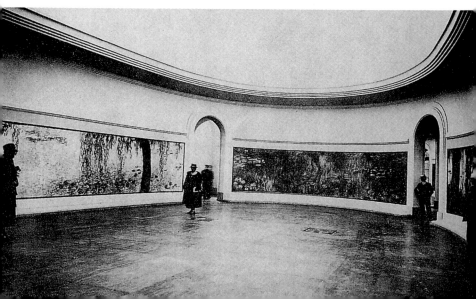

■ Claude Monet, *The Artist's House, View from the Rose Garden*, 1922–24, Musée Marmottan, Paris. At the end of his long, troubled life, Monet's style was still energetic and powerful. Everything was now based on pure, free color. As Paul Valéry commented in 1929, "Reality no longer has precise confines".

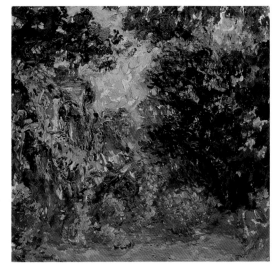

■ Here, Claude Monet and his lifelong friend Georges Clemenceau are photographed on the Japanese bridge at Giverny in 1921.

■ Claude Monet, *The Rose Bush*, 1925–26, Musée d'Orsay, Paris. This late work is an evanescent and delicate blend of cold tones.

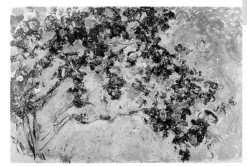

■ Here, Monet's coffin is borne to the cemetery at Giverny on December 8, 1926. Monet did not practice any religion during his life and was interred without prayers.

127

1913–1926

Milestones and frivolities

The decade of Monet's death witnessed politically difficult years, marked by complex events and a precarious economy that led to the crash of the New York stock market. The Wall Street Crash brought the carefree, frivolous Roaring Twenties to an abrupt close. Dadaism had advocated the notion of art as the experience of a mass trend based on transgression and the use of alternative materials, whereas Surrealism went further in the provocative quality of its work and in its denial of academic precepts. Other artists, going against the grain, clung to reality as the essence of their artistic message and stylistic expression, thus paving the way for those artists who in the 1930s would produce actively controversial, socially relevant art. For these new artists, man was an individual, a thinker, who hoped for a new, full life, in which the affirmation of the self was eternal and paramount. Monet had always held this view.

■ *Bergère* desk seat and writing desk, Musée des Arts Décoratifs, Paris, 1925. These items are elegant examples of the 1920s style. Manufactured for the French diplomatic corps in rosewood and leather, they were intended as library furniture.

■ Gio Ponti and Libero Andreotti, *"Siren"* cist, 1928, Castello Sforzesco, Milan. A talented architect, Ponti also worked in the decorative arts. This piece, with its mermaid motifs, is tongue-in-cheek in style.

■ The actress Greta Garbo is pictured in a still from the film *Flesh and the Devil* (1926).

■ In 1927, the concluding part of Marcel Proust's *À la Recherche du Temps Perdu* was published.

■ Joseph Stalin was one of Russia's most influential politicians. An able and ruthless man, he established himself as dictator after Lenin's death. He took over as leader in 1924, dragging the Soviet Union into tyranny.

■ The Great International Exhibition, held in Paris in 1925, saw the triumph of the applied and decorative arts and led to the taste of the period being dubbed Art Deco.

Surrealism in Paris

Surrealism began in Paris in 1924 through the efforts of the poet André Breton, and spread throughout Europe, taking on a number of different stylistic guises. Some of its premises are based on de Chirico's Metaphysical Painting, but its style reveals highly individual approaches, such as that of Joan Miró. His *Carnival of Harlequin*, c.1925, now in the Albright Knox Art Gallery, Buffalo, is shown here.

Monet's legacy

Claude Monet's art evolved over time as the result of the commitment with which he approached his work and the passion that never failed to animate him. Although he was the founder of Impressionism (together with Renoir), he adopted a style from the 1880s that could no longer be described as Impressionist. He started out as part of the movement that was the precursor of the avant-garde trends of the 20th century and became preoccupied with capturing the moment of reality; this continued to elude him, transforming itself instead into something different, "something other". In spite of this, he was never an abstract painter. It is, however, true – especially in the series paintings – that his awareness of reality as something new and utterly different each time it was studied, combined with his obsessive perfectionism, constitutes a very definite link with contemporary art. In retrospect, it is clear that Monet was important for a number of different roles and innovations, including his status as the archetypal Impressionist; his revolutionary technique; and his method of working in series.

■ Claude Monet, *The Water Lily Pond*, 1904, Musée d'Orsay, Paris.

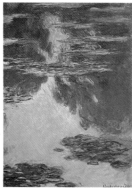

■ Claude Monet, *Water Lilies*, 1907, Museum of Fine Arts, Houston.

■ Claude Monet, *Water Lilies*, 1907, Musée Marmottan, Paris. Monet influenced a great many artists, notably Pierre Bonnard, one of the Nabis group, who kept a photograph of the *Water Lilies* in his studio. The detail shown here reveals the master's consummate skill in handling color.

■ Claude Monet, *Morning*, 1914–26, Musée de l'Orangerie, Paris. Here, Monet takes color beyond form and lets it take over the composition, giving it its own independent voice. Monet recognized how color could express values that were totally free from those of form – a typical feature of contemporary art.

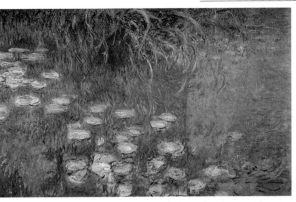

■ Claude Monet, *Water Lilies*, 1915 or 1917, Musée d'Orsay, Paris. Only a few contemporary artists were able to match the unique creative drive behind the water lily paintings. Exhibited many times since the early 20th century, both in Europe and the United States, they have captured the public's imagination through their dazzling range of colors. Artists and critics have also admired the visual dissolution of spatiality that Monet achieved through years of artistic experimentation. Paul Signac wrote: "Generally, when I leave a painting exhibition, I am glad to see the sky, trees and streets again; when I left the *Water Lilies*, everything looked flat and dry to me. I will go back often."

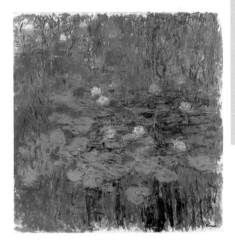

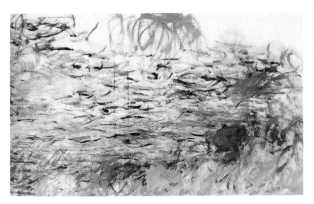

■ Claude Monet, *Water Lilies*, 1917–19, Musée Marmottan, Paris. Monet's failing eyesight prevented him from distinguishing color nuances and detail and his brushstrokes reflected his physical frailty. He may have been nearly blind, but his inner vision remained.

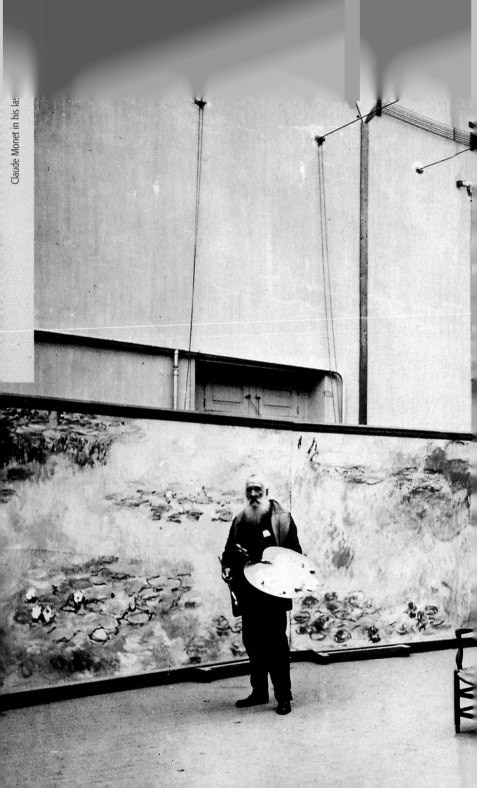

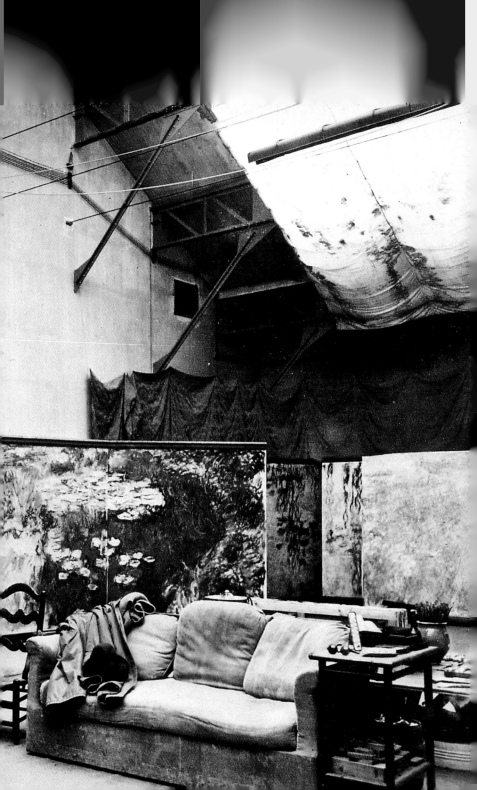

■ The Metropolitan Museum in New York, home to several of Monet's works.

Note

The places listed in this section refer to the current location of Monet's works. Where more than one work is housed in the same **place***, they are listed in chronological order.*

■ Westminster Bridge and the Houses of Parliament, London, the subject of many paintings by Monet.

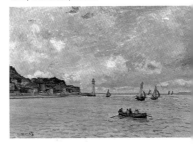

Note

The people mentioned here are artists, intellectuals, politicians, or businessmen who had some connection with Monet, as well as painters, sculptors, and architects who were contemporaries or active in the same places as Monet.

Balzac, Honoré de (Tours, 1799 – Paris, 1850), French writer. The characters in his *Comédie humaine*, a cycle of 95 novels that provides a mercilessly realistic portrayal of 19th-century French society, recur from book to book and take on a life of their own. Detailed descriptions combine with a powerful vision, p. 14.

Banti, Cristiano (Santa Croce sull'Arno, 1824 – Montemurlo, 1904), Italian artist belonging to the *Macchiaioli* group, p. 21.

Baudelaire, Charles (Paris, 1821–67), French poet and art critic. He went against the prejudiced Academy approach by trying to study and understand the work of artists from the vantage point of pre-established canons. He was one of the first to promote the art of Delacroix, Daumier, Corot, and Manet. His collected essays, including *Curiosités esthétiques*, were published posthumously, pp. 14, 24, 34.

Bazille, Frédéric (Montpellier, 1841 – Baune-la-Rolande, 1870), French painter. A friend of Sisley and Monet, he worked alongside the Impressionists, sharing their ideals and painting the same scenes, pp. 26, 31, 32, 34.

Bernheim-Jeune, French art dealer and gallery owner who handled Monet's paintings, p. 112.

Blanche, Jacques-Emile (Paris, 1861 – Offranville, 1942), French painter and art critic. He was influenced by Manet, about whom he wrote an essay, p. 91.

Bonnard, Pierre (Fontenay-aux-Roses, 1867 – Le Cannet, 1947), French painter. He was a founding member of the Nabis group and an admirer of Monet's work, which greatly influenced him, pp. 118, 130.

Borrani, Odoardo (Pisa, 1834 – Florence, 1905), Italian painter belonging to the *Macchiaioli* group, p. 21.

Boudin, Eugène (Honfleur, 1824 – Deauville, 1898), French painter. He always painted subjects from nature, leading Monet to follow the same example. He took part in the first Impressionist exhibition in 1874, pp. 8, 9, 18, 26.

Cabanel, Alexandre (Montpellier, 1823 – Paris, 1889), An Academic painter who was both eclectic and superficial, he staunchly opposed Impressionism, p. 10.

Caillebotte, Gustave (Paris, 1848 – Gennevilliers, 1894), French painter. Although he took part in five of the eight Impressionist exhibitions, he never abandoned Realism. He was a loyal and generous patron and a collector of Impressionist work, pp. 54, 58, 62, 64.

Cassatt, Mary (Pittsburgh, 1845 – Le Mesnil-Théribus, 1926),

■ Mary Cassatt, *Girl Sewing*, 1880–82, Private Collection.

■ Pierre Bonnard, *The Artist's Garden Steps*, 1942–44, Tate Gallery, London.

■ Camille Corot, *View Near Volterra*, 1838, National Gallery of Art, Washington, DC.

American painter and printmaker. She was introduced to the Impressionists by Degas, who presuaded her to show her work with the group. Her paintings are influenced to a certain extent by Japanese art, p.112.

Castagnary, I. A., French critic who praised Claude Monet's work, p. 52.

Cecioni, Adriano (Florence, 1836–86), Italian painter and sculptor belonging to the *verismo* Realist movement. He was one of the main exponents of the *Macchiaioli* group, p. 21.

Cézanne, Paul (Aix-en-Provence, 1839–1906), French painter. Admired by Monet, his artistic experimentation went beyond Impressionism, towards a synthesis of form and volume, pp. 40, 46, 49, 54, 70, 88, 95, 108, 114.

Chagall, Marc (Vitebsk, 1887 – Saint-Paul-de-Vence, 1985),

■ Marc Chagall, *Violin Player*, 1912–13, National Gallery of Art, Washington, DC.

French artist of Russian origin. He created lyrical paintings in which objects and human figures have a symbolic meaning. André Breton considered him to be a forerunner of Surrealism, p. 114.

Champfleury (Laon, 1821 – Sèvres, 1869), pseudonym of Jules Husson, French writer. He wrote novels about the bohemian life, with strongly realistic undertones. He was a staunch supporter of Realism in all its manifestations (he wrote a kind of manifesto about it, called "Le Réalisme") and defended the work of Gustave Courbet and Honoré Daumier, p. 13.

Charpentier, Georges, French publisher and founder of the periodical *La vie moderne* in 1879, at whose offices Monet held his first one-man exhibition, p. 66.

Chevreul, Eugène (Angers 1786 – Paris, 1889), French chemist. He developed a theory of color that would have great importance for the so-called Post-Impressionist artists, pp. 24, 73.

Clemenceau, Georges (Mouilleron-en-Pared, 1841 – Paris, 1929), politician and lifelong friend of Monet's. He shared a prolific correspondence with the artist, pp. 26, 86, 92, 112, 122, 126, 127.

Comte, Auguste (Montpellier, 1798 – Paris, 1857), French philosopher regarded as the father of positivism, p. 15.

Constable, John (East Bergholt, 1776 – London, 1837),

English painter. His work, in which certain subjects frequently recur, is composed mainly of landscape painting, and is characterized by a a direct and deep understanding of nature. He influenced Delacroix and the Barbizon School artists, pp. 10, 38.

Corot, Jean-Baptiste-Camille (Paris, 1796–1875), French painter. His work was an important source of reference for the Impressionists. He advocated precise draughtsmanship (the legacy of his classical studies) and an exhaustive quest for color and light, pp. 9, 18.

■ Gustave Courbet, *Bathers*, 1853, Musée Fabre, Montpellier.

■ Charles-François Daubigny, *The Seine at Bezons*, Musée du Louvre, Paris.

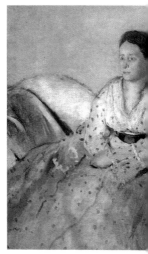

Courbet, Gustave (Ornans, 1819 – Vevey, 1877), French painter. Virulently nonconformist and revolutionary by nature (he took part in the Paris Commune and was imprisoned), he is considered to be the leading artist in French Realism. He saw the common working man (*The Stone Breakers*, 1848) as the new hero of history. He was sentenced to six months' imprisonment for demolishing the Vendôme column, built in honor of Napoleon, and died in exile in Switzerland, financially ruined, pp. 13, 18, 19, 32, 37, 60.

Couture, Thomas (Senlis, 1815 – Villiers-le-Bel, 1879), French painter. A prominent Academician, he exploited his position to hold nonconformsist artists to ransom and exclude their work from the Salon. He painted mainly cold, rather artificially composed historical scenes, and, more successfully, portraits. Manet was among his students, p. 18.

Daubigny, Charles-François (Paris, 1817–78), French painter. A landscape artist and scrupulous observer, his attempt to convey atmosphere in his work marked the Barbizon School's shift

towards Impressionism. He set up his studio on a houseboat at Auvers-sur-Oise. He came out in support of Monet at the Salon of 1869, pp. 18, 40.

Daumier, Honoré (Marseilles, 1808 – Valmondois, 1879), French painter. The greatest caricaturist of his time, he began by publishing his work in politically

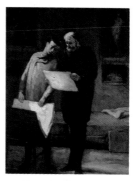

■ Honoré Daumier, *Advice to a Young Artist*, after 1860, National Gallery of Art, Washington, DC.

satirical periodicals, for which he got into some trouble and was even imprisoned for a few months. Unquestionably linked to Realism through his natural inclination and choice of subject-matter (*The Judges*, 1850; *The Third-Class Carriage*, 1862), he distanced himself from it, deploring the term. He can be regarded as a forerunner of Expressionism through the extreme freedom of his work, his meticulous attention to detail, and his distortion of form, pp. 12, 13, 25, 60.

Debussy, Claude (Saint-Germain-en-Laye, 1862 – Paris, 1918), French composer. He was receptive to models suggested by the Symbolist writers and Impressionist artists, p. 88.

Degas, Edgar (Paris 1834–1917), French painter. Initially inspired by Ingres, his work was influenced by photography and Japanese prints. A friend of the Impressionists, with whom he exhibited his work on several occasions, he did not share their fondness for working in the open air. He preferred instead interior scenes inspired by the world of ballet dancing (*The Dance School*, 1874; *Ballerina at the Barre*, 1880) or by the everyday life of women (*Women Ironing* and *Dressmakers*, 1882–83; *Ladies at their Toilet*, 1885–98). He studied the effects of artificial light, often using techniques taken from photography. A ruthlessly accurate observer, he always eschewed any kind of idealization, pp. 21, 40, 55, 60, 61, 73.

Delacroix, Eugène (Carenton-Saint-Maurice, 1798 – Paris, 1863), French painter, one of the masters of the Romantic period,

■ Edgar Degas,
Madame René de Gas,
1872–73, National
Gallery of Art,
Washington, DC.

and a friend of Géricault. His
works (*Liberty Leading the People*
and *The Death of Sardanapalus,*
1827) treat quintessentially
Romantic themes, from patriotism
to exoticism, pp. 13, 18, 25.

Derain, André (Chatou, 1880 –
Garches, 1954), French painter. At
the heart of avant-garde activities
in the early part of the 20th
century, he was a member of the
Fauves, before moving towards
Cubism, p. 109.

Descaves, Lucien (Paris,
1861–1949), French writer and
journalist whose writings praised
Monet and his paintings in
eulogistic terms, p. 107.

De Tivoli, Serafino (Leghorn,
1826 – Florence, 1892), Italian
painter. He met Manet and
Courbet in Paris and was
influenced by the wave of
Realism, introducing its
theories to Italy. p. 21.

Doncieux Monet, Camille
(died Vétheuil, 1879), Monet's
first love and his model. She
married him in 1870 and bore
him two sons, Jean (1867) and
Michel (1878), pp. 26, 31, 32,
38, 46, 47, 58, 64, 65, 112.

Durand-Ruel, Paul (Paris
1831–1922), French art dealer
and gallery owner. He always
defended the Impressionists and
their work, mounting exhibitions
of their paintings in his Paris
gallery and in its various branches
in Europe and New York, pp. 39,
46, 54, 58, 60, 64, 66, 70, 82, 86,
100, 106, 107, 112, 119, 125.

Duranty, Louis Edmond
(Paris, 1833–80), French
writer. He was part of the
Realist movement; a friend of the
Impressionists, he praised their
work in his essay *La Nouvelle
Peinture,* published in 1876, p. 54.

Fattori, Giovanni (Leghorn,
1825 – Florence, 1908),
Italian painter. A member of
the *Macchiaioli* group, of which
he remains one of the most
successful exponents, he
produced mainly historical
paintings and military scenes
(*The Italian Camp after the
Battle of Magenta*). Simplicity,
rigor, and the harsh reality of
history are the salient features
of his work, pp. 21. 24.

Gaudibert, Louis-Joachim,
French collector, who helped
Monet by commissioning portraits

from him and buying back the
paintings seized by the artist's
creditors, pp. 32, 33.

Gauguin, Paul (Paris, 1848 –
Marquesas Islands, 1903),
French painter. Introduced to
painting by Pissarro, he was
briefly an Impressionist but
soon abandoned the style. He was
attracted by the art of Van Gogh,
with whom he shared an intense
friendship; this ended abruptly
in 1888 following serious
disagreements between them.
Constant money worries and his
innate restlessness drove him
to seek escape in exotic places
such as Tahiti and the Marquesas
Islands. These visits marked the
development of his art towards
primitive influences, pp. 52,
66, 79, 84, 102.

Geffroy, Gustave (Paris,
1855–1926), writer and critic for
the newspaper *La Justice,* friend
and staunch defender of Monet,
pp. 76, 111.

Géricault, Théodore
(Rouen, 1791 – Paris, 1824),
French painter. His *Raft of the
Medusa* (1819), which caused an
uproar for its realism, was a
manifesto for Romanticism. It

■ Paul Gauguin, *The
Vision after the Sermon,*
1888, National Gallery of
Scotland, Edinburgh.

■ Camille Pissaro,
Flowering Orchard, 1872,
National Gallery of Art,
Washington, DC.

combined vigor, movement, a powerful sense of tragedy and pathos, and a tendency towards morbidity, p. 25.

Gleyre, Marc-Charles-Gabriel (Chevilly, 1806 – Paris, 1874), famous painter of historical subjects. Monet attended his studio in 1862–63, where he met Bazille, p. 26.

Helleu, Paul (Vannes, 1859–1927), French painter, he executed elegant pastel portraits in the manner of Whistler, p. 91.

Hodler, Ferdinand (Berne, 1853 – Geneva, 1918), Swiss artist. His dreamlike Symbolist paintings make him an important Jugendstil artist, p. 84.

Hoschedé, Alice (died 1911), wife of Ernest Hoschedé. She had a relationship with Monet, which became official after the death of Camille; in 1882, she became his wife, pp. 53, 70, 86, 112.

Hoschedé, Blanche, daughter of Alice and Ernest Hoschedé, wife of Monet's son, Jean. She remained close to Monet in his later years, nursing him through his final illness, pp. 118, 126.

Hoschedé, Ernest (died Paris, 1891), French collector. He purchased a large number of Monet's works and after the sale of his art collection, he chose to live with his wife and six children with Monet and his family in the house at Vétheuil. He was declared bankrupt in 1877, pp. 53, 58, 86.

Huysmans, Georges Charles, known as Joris-Karl (Paris, 1848–1907), French writer. Having first embraced the Realism put forward by Émile Zola, he abandoned it to become the leading figure in Decadent writing, with his 1884 novel *À Rebours*, p. 76.

Jongkind, Johann Barthold (Lattrop, 1819 – Côte Saint-André, 1891), Dutch painter who worked in France and Holland. A fine landscape artist, he favored watercolor. His paintings exercised a great influence on Monet, pp. 19, 26.

Kandinsky, Wassily (Moscow, 1866 – Neuilly-sur-Seine, 1944), Russian painter. Co-founder of Der Blaue Reiter (Blue Rider), he established himself as the main exponent of non-geometric abstract art. As a young man, he was particularly inspired by Monet's *Haystack* paintings, pp. 83, 108, 125.

Klee, Paul (Münchenbuchsee, 1879 – Muralto, 1940), Swiss painter. Originally part of Der Blaue Reiter, he developed an extremely free painterly language, in which reality and imagination are mingled with irony and a surface naivety, p. 125.

Klimt, Gustav (Vienna, 1862–1918), Austrian painter. The major exponent of the Viennese Secession, the symbolic elements in his works are achieved through harmoniously worked out decorative rhythms (*The Bride*, 1917–18), pp. 85, 108.

Lecadre, Jeanne-Marguerite, Monet's adopted aunt, she looked after him after his mother's death until he was 17. An amateur artist in her own right, she encouraged him to persevere in his artistic efforts and also helped him out financially, pp. 18, 32.

Lega, Silvestro (Modigliana, 1826 – Florence, 1895), Italian painter. A member of the *Macchiaioli* group, he painted bourgeois interiors, affectionately studying the banality of their decoration. Eventually, he abandoned the objectivity of such scenes in favor of a more lively, loose style, in which color and light were more important than clear drawing, p. 21.

Leroy, Louis, French critic. He published a satirical article, poking fun at the title of Monet's painting *Impression: Sunrise* in the periodical *Le Charivari* on April 25, 1874, which led to the disparaging sobriquet "Impressionists", p. 52.

Manet, Edouard (Paris 1832–83), French painter. A pupil of Couture, he never got on with his teacher. Although he mixed with the Impressionists, he formed closer friendships with writers. Zola's praise for Manet's consistently nonconformist paintings (*Le Déjeuner sur l'Herbe*, 1862; *Olympia*, 1863) even cost him his job as a critic. Manet's modernity consists of revisiting the way in which space is defined, giving value to outlines and treating volume by means of large areas of color with no shading. He explored painting beyond its strict representational function

■ Pierre-Auguste Renoir, *Bather Smoothing her Hair*, 1893, National Gallery of Art, Washington, DC.

Celebrated French photographer, designer, and writer. Nadar edited several periodicals and in 1854 published the *Panthéon Nadar*, a collection of portraits of famous contemporary figures. The First Impressionist Exhibition was held at his studio in Boulevard des Capucines in Paris in 1874, pp. 13, 49, 52, 54, 92.

and submitted it to his own laws, paving the way for 20th-century art, pp. 18, 24, 25, 29, 31, 34, 35, 37, 41, 42, 52, 62, 67, 82.

Matisse, Henri (Le Cateau, 1869 – Cimiez, 1954), French painter and sculptor. His constant experimentation with color brought him close to the artistic avant-garde, but he always retained his own individuality. His works are characterized by vibrant colors and distorted lines, which earned him the appellation *fauve* (wild beast), p. 109.

Maupassant, Guy de (Château de Miromesnil, 1850 – Paris, 1893), French writer. He excelled in the short story medium (*Boule de suif*, 1880), pp. 71, 81.

Millais, John Everett (Southampton, 1829 – London, 1896), English painter. A member of the Pre-Raphaelite Brotherhood (1848), a group of artists who aspired towards the authenticity and simplicity of art before Raphael, he soon embraced a refined literary aestheticism, characterized by ambiguity and morbid references, pp. 14, 15.

Millet, Jean-François (Gruchy, 1814 – Barbizon, 1875), French painter. Disliking city life, he settled at Barbizon and although he knew the so-called Barbizon School artists, he did not belong to their group. He painted landscapes and laborers working in the fields, rustic themes for which he is now best remembered, pp. 10, 15.

Mirbeau, Octave (Trévières, 1848 – Paris, 1917), French writer. He defended the work of his friend Monet in reviews, pp. 70, 82, 106, 113, 122.

Monet, Jean (Paris, 1867 – 1914), firstborn son of Monet and Camille. He married Blanche, one of the daughters of Alice Hoschedé, Monet's second wife, pp. 32, 46, 112, 118.

Monet, Michel (born, Paris, 1878), the second son of Monet and Camille; his mother died not long after his birth, p. 58, 118.

Morisot, Berthe (Bourges, 1841 – Paris, 1895), French painter. She studied painting with Corot, knew Manet, whose sister-in-law she became, and encouraged his interest in painting *en plein air*, acting as his model. She took part in the First Impressionist Exhibition (1874) and regularly exhibited with the group afterwards. She favored intimate portraits and domestic scenes in delicate colors. The influence of Renoir led to a greater concentration in her work on form pp. 35, 52, 54, 55.

Morris, William (London 1834–96), English artist. A writer, painter, designer, decorator, and theorist, Morris wanted to revive and stress the importance of the crafts aspect of the applied arts, specifically within the field of decoration. He had a profound influence on the nascent Art Nouveau movement, pp. 25, 94.

Nadar, pseudonym of Félix Tournachon (Paris, 1820–1910),

Paxton, Joseph (Milton Bryant, 1801 – Sydenham, 1865), English architect. An inspired builder, he designed the Crystal Palace for the Great Exhibition held in London in 1851, p. 20.

Petit, Georges, French gallery owner and art dealer. He bought and promoted Monet's paintings; in 1889, he mounted an exhibition of works by Monet and Rodin in his gallery, pp. 70, 76, 82.

Pissarro, Camille (Saint-Thomas, 1830 – Paris 1903), French painter. He was part of the Impressionist group, painting outdoor scenes in which he abolished linear contours and grey shades and stressed the importance of visual experience in the perception of reality, pp. 18, 38, 40, 54, 55, 58, 70, 94, 106.

Proust, Marcel (Paris, 1871–1922), French writer and author of the celebrated *À la recherche du temps perdu*, considered one of the most important works in the history of modern prose, p. 129.

■ Théodore Rousseau, *Oak Trees*, Musée du Louvre, Paris.

■ Georges Seurat, *The Lighthouse at Honfleur*, 1886, National Gallery of Art, Washington, DC.

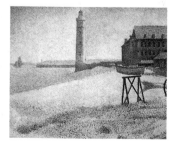

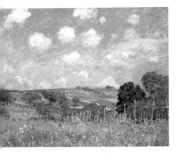

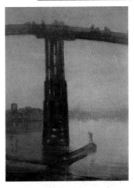

(*The Bridge at Argenteuil*, 1872).
His work was never recognized:
excluded from the Salons, he
fared no better with collectors
and died in penury. It was only in
the 20th century that his painting,
particularly his landscapes, gained
the acclaim they deserved, pp. 26,
27, 40, 52, 54, 60.

Tiffany, Louis Comfort
(New York, 1848–1933), American
painter and designer. Tiffany
was one of the leading figures
of American Art Nouveau, taking
a particular interest in hand-
blown glass, p. 72.

Troyon, Constant (Sèvres, 1810
– Paris, 1865), French landscape
artist connected with the
Barbizon School, p. 18.

Toulmouche, Auguste Claude,
genre painter, and prize-winner
at the 1861 Salon, he introduced
Monet to the studio of
Charles Gleyre, p. 26.

Toulouse-Lautrec, Henri de
(Albi, 1864 – Malromé, 1901),
French painter. With his elegant
style – a forerunner of Art
Nouveau – he became the
satirical chronicler of Parisian
nightlife (*At the Moulin Rouge*,
1892), pp. 88, 102.

**Turner, Joseph Mallord
William** (London, 1775–1851),
English painter. His celebrated
works are characterized by a
highly individual and powerful
treatment of light. He is regarded
as a forerunner of Impressionism,

but his denial of any kind of
descriptive prop in his paintings
also makes him the father of
lyrical abstractionism, pp. 38,
39, 51, 63, 101.

Van Gogh, Theo (Groot
Zundert, 1857 – Paris, 1891),
Dutch art dealer and brother
of Vincent, he bought works
by Monet, p. 76.

Van Gogh, Vincent (Groot
Zundert, 1853 – Auvers-sur-
Oise, 1890), Dutch painter.
He discovered Impressionism
in Paris in 1886 and studied
Japanese prints and pointillism.
Driven by an inner turmoil, he
progressed from light, intense
Impressionistic shades to the
use of more violent colors and
a desperate, almost febrile
deformation of forms (*Starry
Night*, 1889). His work was not
successful but constituted an
important source of reference
for subsequent generations
of artists, pp. 52, 79, 102.

Verlaine, Paul (Metz, 1844 –
Parigi, 1896), French poet, one of
the so-called *poètes maudits*, and
friend of Rimbaud. In contrast to
the disorder of his private life, his
verse is languid and musical, p. 94.

Vollard, Ambroise (Saint
Denis, Ile de la Réunion, 1868 –
Paris, 1939), French art dealer
and galllery-owner. He played a
fundamental role in the history
of painting in that he mounted
the first exhibitions of Manet,
Cézanne, and many others. He

promoted their work regardless
of the contempt and negative
criticism such artists provoked
at that time, p. 88.

**Whistler, James Abbott
McNeill** (Lowell, 1834 –
London, 1903), American artist and
engraver. His painterly technique,
influenced by Japanese prints,
tended towards subtle color
schemes in white, grey, and
black, pp. 51, 112.

Zola, Émile (Paris, 1840–1902),
French writer. The most prominent
figure within the Realist trend, he
wrote the *Rougon-Macquart* cycle
of novels (1871–93), in which the
moral dissolution that followed
the defeat of ideals in 1848 is
experienced by a working
family, damaged by alcoholism.
Germinal (1885) is possibly his
masterpiece, pp. 28, 37, 70, 78.

A DK PUBLISHING BOOK
Visit us on the World Wide Web at http://www.dk.com

TRANSLATOR
Anna Bennett

DESIGN ASSISTANCE
Joanne Mitchell

EDITORS
Louise Candlish, Fergus Day

MANAGING EDITOR
Anna Kruger

Series of monographs
edited by Stefano Peccatori and Stefano Zuffi

Text by Paola Rapelli

PICTURE SOURCES
Archivio Electa, Milan
Elemond Editori Associati wishes to thank all those museums and
photographic libraries who have kindly supplied pictures, and would be pleased
to hear from copyright holders in the event of uncredited picture sources.

Project created in conjunction with
La Biblioteca editrice s.r.l., Milan

First published in the United States in 1999 by DK Publishing Inc.
95 Madison Avenue, New York, New York 10016

ISBN 0-7894-4142-X

Library of Congress Catalog Card Number: 98-86756

First published in Great Britain in 1999
by Dorling Kindersley Limited,
9 Henrietta Street, London WC2E 8PS

A CIP catalogue record of this book is available from the British Library.

ISBN 0751307270

2 4 6 8 10 9 7 5 3 1

Printed by Elemond s.p.a. at Martellago (Venice)